TWENTY

FLORIDA

PIRATE

TWENTY FLORIDA PIRATES

BY
KEVIN M. MCCARTHY

ILLUSTRATIONS BY
WILLIAM L. TROTTER

PINEAPPLE PRESS, INC.
SARASOTA, FLORIDA

DEDICATION
To my lovely wife, Karelisa Hartigan.
To my children, Katie, Brendan, Erin, and Matthew.
And to my stepson, Timothy Hartigan.

Text Copyright © 1994 by Kevin M. McCarthy
Illustrations Copyright © 1994 by William L. Trotter

Inquiries should be addressed to:
Pineapple Press, Inc.
P.O. Drawer 16008
Southside Station
Sarasota, Florida 34239

LIBRARY OF CONGRESS
CATALOGING-IN-PUBLICATION DATA
McCarthy, Kevin
 Twenty Florida Pirates / by Kevin M. McCarthy. — 1st ed.
 p. cm.
 Includes bibliographical references (p.) and index.
 ISBN 1-56164-050-6
 1. Pirates—Florida—History. 2. Florida—History, Naval.
I. Title.
F311.5.M37 1993
910'.9163'48—dc20 93-48310
 CIP

First Edition
 10 9 8 7 6 5 4 3 2 1

Design by Frank Cochrane Associates
Composition by Cynthia Keenan

Printed in Hong Kong

TABLE OF CONTENTS

PREFACE

When one thinks of Florida pirates, different images may come to mind. Someone in Bradenton might think of baseball's Pittsburgh Pirates, who have spring training there. Someone in Fernandina Beach might think of the nickname of the local high school. Someone in the computer or music industries might think of software pirates who steal programs or songs without permission.

For this book think other thoughts. Think about Blackbeard as he lit a match to his hair and led his brigands into battle with smoke billowing around his face. Think about William Augustus Bowles as he urged his Indians on to attack ships in the Gulf of Mexico. Think about modern-day drug smugglers lying in wait for yachts crossing the Gulf Stream. All of these are pirates, whom we will define as those who rob or commit illegal violence at sea or on the shores of the sea.

My own association with pirates goes back to my birth. When I was born in 1940 in New Jersey, my parents were really not expecting me. They knew my twin brother was coming, but not me. Then, as now, the parents had to choose a name for their newborns before the hospital would allow them to take their children home. My brother came along first and was named Dennis after our father. Ten minutes later, I arrived, but my surprised parents did not have a name picked out for me. Just before I was born, my mother had been reading a story about a Spanish pirate and therefore named me after him: Orlando. When my father came to the hospital and learned about my proposed name, he pointed out that Kevin Michael McCarthy would be a more appropriate name. For one brief moment, then, I was an Irish-American named after a Spanish pirate.

Enjoy these tales about a darker side to our state's history. Relive the past as you examine the illustrations by maritime painter William Trotter. Thank your lucky stars that you don't live at a time when the seas were so dangerous to sail on. But, if you happen to be cruising those seas alone now, be on the alert for any would-be modern pirates who would not hesitate to send all on board your boat to the bottom of the sea.

Kevin M. ("Orlando") McCarthy
Gainesville, Florida

\mathcal{T}IMELINE

History of Florida	Pirates
Ponce de Léon discovers Florida (1513)	
Pedro Menéndez de Avilés establishes St. Augustine (1565)	Sir John Hawkins (1565)
	Sir Francis Drake (1586)
	Robert Searles (1668)
	San Marcos Pirates (1682)
	St. Augustine Pirates (1683)
	Andrew Ranson (1684)
Spain establishes a settlement at Pensacola (1698)	
	Black Caesar (1700)
	Henry Jennings (1715)
	Blackbeard (1718)
British General Oglethorpe invades Florida (1740)	
	Francisco Menéndez (1741)
Spain cedes Florida to England (1763)	
England returns Florida to Spain (1783)	
	José Gaspar (1800)
	William Augustus Bowles (1801)
Andrew Jackson captures Pensacola (1814)	
	Luis Aury (1817)
	Pirates in the Florida Keys (1819)
	Jean Lafitte (1819)
U.S. takes over Florida from Spain (1821)	
	Don Pedro Gilbert (1832)
Florida's first railroads (1834)	
Seminole War begins (1835)	
Seminole War ends (1842)	
Florida becomes a state (1845)	
	Slave traders (1860)
Florida withdraws from the Union and joins the Confederacy (1861)	
Florida fights in the Civil War (1861-65)	
Florida rejoins the Union (1868)	
Flagler's railroad reaches Key West (1912)	
	Liquor pirate (1929)
U.S. launches satellite from Cape Canaveral (1958)	
	Drug smugglers (1977)
120,000 Cuban refugees arrive in Florida (1980)	
Florida becomes 4th in the nation in population (1990)	
	Yachtjackers (1993)

INTRODUCTION

This book presents twenty Florida pirates, but many more probably roamed along its coasts preying on ships and towns. We examine these twenty in some detail because they are well-documented and because they represent the different types of pirate, from the English Hawkins and Drake to the modern-day brigands who use advanced technology to attack ships.

Who were the pirates?
The picture that many have had of pirates includes a swashbuckling seaman with a black patch over one eye, a bright bandanna around his neck, a sharp cutlass in one hand, and a brace of pistols tucked in his waistband. Actors like Errol Flynn, Doug McClure, and Anthony Quinn did much to create that devil-may-care attitude that we admired in cinematic pirates. Despite the glamorous picture that writers and film directors have given us of pirates, they were in fact cruel, greedy, dastardly brigands. Then why have we tended to glamorize such criminals in our literature and media? Perhaps because they led an adventurous life free of the laws and conventions that most of society abides by. Perhaps because they stood up against authority and oppressive conditions on the navies' ships. Perhaps because they were brave and daring and reckless.

Those who knew pirates firsthand had a different picture of them than did writers like Robert Louis Stevenson, author of *Treasure Island*. For example, an 1837 book entitled *The Pirates Own Book* began by describing how many seamen felt about pirates:

In the mind of the mariner, there is a superstitious horror connected with the name of Pirate; and there are few subjects that interest and excite the curiosity of mankind generally, more than the desperate exploits, foul doings, and diabolical career of these monsters in human form. A piratical crew is generally formed of the desperadoes and runagates [renegades] of every clime and nation.... The pirate is truly fond of women and wine, and when not engaged in robbing, keeps maddened with intoxicating liquors, and passes his time in debauchery.... (pp. 3-4)

As we see throughout this book, those innocent victims who experienced the cruelty of a Blackbeard or a James Alderman came to loathe such criminals and could be adversely affected for the rest of their lives, if in fact they lived to reach the safety of shore.

Even deciding who the pirates were has not been easy since a pirate to one nation may be a hero to another. While the English considered Sir Francis Drake a great man, a hero, the Spanish thought of him as a pirate, a man they called The Dragon. By the same token, Americans considered John Paul Jones a hero, but the English branded him a pirate. Much depended on what nation the seaman was fighting against and also his success. When Francis Drake triumphantly returned to England with loot valued at 600,000 English pounds, equivalent to 20 million pounds today, his countrymen praised him extravagantly. If he had lost ships and many of his men, his countrymen might easily have turned on him.

How do we know about the pirates?
Few of the pirates left behind any written records as to what they did and what they thought or even who they really were. These men and women were usually too busy attacking ships, drinking and carousing, and trying to stay alive, and, even if they had wanted to, many if not most of them were illiterate, which was true of many seafarers in history. Many pirates died young either at the end of a battle or the end of a rope.

Those that did not, for example the relatively few who made a big strike and retired or who took advantage of a royal pardon, would not have wanted to brag to their law-abiding neighbors about how they had accumulated so much wealth, so they just kept it to themselves. A few pirates took advantage of the occasional amnesty offered them, but many

of them soon became disenchanted with the quiet life of respectability and sought more adventure and riches, maybe even a return to plundering ships. The pirates we describe in this book are those we have sufficient details about, but others surely sailed in Florida waters. We just do not have enough information about them.

Much of what we know about pirates comes from the official reports that the U.S. Navy kept as it pursued the pirates around Florida waters, from newspaper accounts, or from eyewitness statements from those whom the pirates spared. Admiralty trials in England and their counterparts in America, as well as the accounts of pardoned pirates, tell us much about their lives and deeds. Among the early books is one of particular use because of its first-hand knowledge of pirates and their victims: Captain Charles Johnson's *A General History of the Robberies and Murders of the Most Notorious Pyrates*. First published in London in 1724 and then reprinted dozens of times, this book is the work of one of English literature's great writers, Daniel Defoe, the author of *Robinson Crusoe,* a writer who used various aliases, for example Captain Charles Johnson.

Why did men and women become pirates?
Pirates often came from the maritime service, especially when the arrival of peace made their skills unnecessary for nations trying to save money. They found it far easier to continue preying on ships rather than returning to the dull, tedious, low-paying jobs on shore. Mutineers were easy recruits since they knew what they faced if captured by the nation they were mutineering against. Sometimes new pirate recruits came from captured ships and chose the dangers of pirating to the chance they would be killed by the brigands. When pirates captured a slave ship or prisoner ship, the prisoners could be induced to join the pirates rather than being sent to another prison ship. Chroniclers even claim that Major Stede Bonnet became a pirate to escape a nagging wife.

Non-British nations also encouraged piracy after Britain passed the Navigation Act in 1696 to prohibit all nations, except England, from trading with English colonies. Colonists, for example those in North America, decided to risk trading with the pirates, from whom they could obtain goods far more cheaply and easily than by trading directly with En-

gland. Local officials were unable and unwilling to cut off their contact with the pirates, especially if the latter were offering bribes. The type of collusion that Blackbeard had with North Carolina officials was all too common in those days, and much of it was probably secretly done. The British Navy was simply too undermanned to patrol the North American coast effectively, and the pirates were able to earn a comfortable living by trading with the colonies.

How did pirates live?
Contrary to what some might believe, the daily life of the pirates was dull and tedious. They did not engage in constant marauding and attacking, but rather had to maintain their ships, keep a lookout posted for targets, and hide from roving patrols. Even when a ship loomed on the horizon, the pirates would check it out carefully, gauging whether it offered enough inducement to risk capture and death. They tended to avoid armed confrontation if at all possible, since their own survival was the number one priority. True, they operated on a "No prey, no pay" policy which necessitated that they venture forth from time to time, but they were reluctant to risk injury or death. They were also careful about the cargo of plundered ships since damaged or lost goods affected the pirates directly.

Homosexuality thrived among the pirates, especially since some of their captains refused to take on as crew members any married men on the theory that married men would be hesitant about risking their lives and might want to spend too much time with their families. Many boys served on pirate ships, and that may have encouraged homosexuality. Some pirate chiefs like Bartholomew Roberts would not allow women and boys on his ships, but others allowed boys to serve. When pirates went ashore to unwind or recover from a raid, they often visited brothels and contracted venereal diseases; Blackbeard demanded medicine, probably for such diseases, when he held the citizens of Charleston hostage.

Gambling was a common vice among the pirates, whether to relieve the incessant boredom or to have a way to use their ill-gotten gains. Such gambling sometimes led to violent quarrels and duels and death. Along with gambling went heavy drinking,

often as a way to forget their tedious lifestyle or as a way to prove their manhood; some historians report that pirates looked on teetotalers as a threat to their brotherhood, that such men were not to be trusted. The heavy liquor helped them all forget the fact that they would not be going home, ever, and that they would most likely end their lives at sea or on an isolated island.

The heavy drinking, as well as the expenses of daily living, used much of the cash they accumulated from their plundering. The result was that they probably hid very little of their booty, despite constant rumors to the contrary. Those rumors were sometimes started by pirates on the scaffold who hoped to postpone or avoid the gallows if they could convince the jailers that treasure was theirs for the taking, if they would only release the pirates to allow them to show the jailers where the treasure was. Even pirate captains could not amass great sums at the expense of their crew because the quartermaster saw to it that everyone shared in the booty according to strict rules of division. Treasure seekers continue to spend enormous amounts of time and money looking for those treasures, but very seldom turn up anything of value.

How did pirates die?

John James Audubon, the great ornithologist who visited Key West in the early 1800s, wrote a story called "Death of a Pirate" that he heard while there. It tells the story of a nameless officer who came upon a dying pirate on an island in the Gulf of Mexico, perhaps in the Marquesas to the west of Key West. The officer came upon a small yawl whose sides were stained with blood. In the boat he found two bloodied corpses and nearby he came upon a dying pirate. When the officer beseeched the man to confess his sins and make amends with his god, the dying man responded:

I am an outlaw, perhaps you will say a wretch — I have been for many years a Pirate. The instructions of my parents were of no avail to me, for I have always believed that I was born to be a most cruel man. I now lie here, about to die in the weeds, because I long ago refused to listen to their many admonitions. Do not shudder when I tell you — these now useless hands murdered the mother

whom they had embraced. I feel that I have deserved the pangs of the wretched death that hovers over me; and I am thankful that one of my kind will alone witness my last gaspings. (p. 29)

After his death, the officer buried him in the sand, probably a resting place similar to that of many other pirates.

Among the crimes that pirates could kill other pirates for were desertion, cowardice, and the concealing of loot of as small a value as one piece of eight. A man convicted of such a crime could face either death by firing squad or marooning. Many pirates actually preferred the former because marooning meant a slow, painful death from starvation or dehydration. The rest of the crew would place him on an abandoned island, often with a pistol and some ammunition with which to end his life when the hunger and thirst became unbearable. The frequency that crews practiced this deed led to their being called "marooners."

The constant threat of death, either through capture or battle or disease, was indicated in their flag, called the Banner of King Death, Black Flag, or Jolly Roger. The origin of the last term may go back to the French buccaneers who used the phrase "joli rouge" or "pretty red" to describe their blood-red flag; illiterate pirates of other nations turned the "joli rouge" into "Jolly Roger" and applied it to the black flag used by pirates. Or it goes back to the phrase Muslim pirates in Indonesia used for themselves, "Ali Raja," meaning "King of the Sea"; non-Muslims may have equated the phrase with the red flag those pirates used and corrupted it to "Olly Raja," "Olly Roger," "Jolly Roger."

The common design of a white skull and crossed thigh bones on a black background was a symbol of death used on gravestones of the day. Captains of merchantmen might draw a skull and cross bones in the margin of their ships' logs to indicate that a crewman had died. Other pirate flags had a skeleton holding an hourglass, sword, glass of rum, or a bloody dart. These symbols of violence, limited time,

and death were meant to remind the pirates of their perilous state so that they would fight even harder, but they were also a warning to prospective prey to avoid fighting and surrender meekly, in hopes that the pirates would spare their lives.

English writer Charles Kingsley described the bittersweet life of a pirate and the end of his marauding career in his poem entitled "The Last Buccaneer" in 1857. The poem alludes to the "fair and free" laws among the pirates, their democratic election of leaders, and the idyllic life they all led on a beautiful island, before they had to face the reality of the "King's ships." The Isle of Avès is an isolated island in the Caribbean Sea 350 miles north of Venezuela and 70 miles west of Dominica.

> OH England is a pleasant place for them that's rich and high,
> But England is a cruel place for such poor folks as I;
> And such a port for mariners I ne'er shall see again
> As the pleasant Isle of Avès, beside the Spanish main.

> There were forty craft in Avès that were both swift and stout,
> All furnished well with small arms and cannons round about;
> And a thousand men in Avès made laws so fair and free
> To choose their valiant captains and obey them loyally.

> Thence we sailed against the Spaniard with his hoards of plate and gold,
> Which he wrung with cruel tortures from Indian folk of old;
> Likewise the merchant captains, with hearts as hard as stone,
> Who flog men and keel-haul them, and starve them to the bone.

> Of the palms grew high in Avès, and fruits that shone like gold,
> And the colibris and parrots they were gorgeous to behold;
> And the negro maids to Avès from bondage fast did flee,
> To welcome gallant sailors, a-sweeping in from sea.

> Oh sweet it was in Avès to hear the landward breeze,
> A-swing with good tobacco in a net between the trees,
> With a negro lass to fan you, while you listened to the roar
> Of the breakers on the reef outside, that never touched the shore.
> But Scripture saith, an ending to all fine things must be;
> So the King's ships sailed on Avès, and quite put down were we.
> All day we fought like bulldogs, but they burst the booms at night;
> And I fled in a piragua, sore wounded, from the fight.

> Nine days I floated starving, and a negro lass beside,
> Till for all I tried to cheer her, the poor young thing she died;
> But as I lay a-gasping, a Bristol sail came by,
> And brought me home to England here, to beg until I die.
> And now I'm old and going – I'm sure I can't tell where;
> One comfort is, this world's so hard, I can't be worse off there:
> If I might but be a sea-dove, I'd fly across the main,
> To the pleasant Isle of Avès, to look at it once again.

Did pirates change history?

Probably. They certainly helped France and England and Spain in their various maritime wars against other European navies. Closer to home, they preyed on ships up and down the Florida coast, harassed coastal towns, even attacked settlements, for example the Spanish salvagers trying to recover treasure from shipwrecks. Pirates improved the technology that led to better, faster boats which they themselves used or which the Coast Guard used to pursue them. The pirates have given fiction writers and movie directors lots of material for novels and films as well as providing the Tampa and Marathon chambers of commerce inspiration for pirate festivals. Not to mention the Tampa Bay Buccaneers and the Fernandina High School Pirates.

When Roman general and statesman Julius Caesar (100-44 B.C.) had managed to annoy some powerful rulers in Rome at an early age, he found it expedient to leave the city and sail for the island of Rhodes. On his way there his ship was attacked by

pirates, who held him for a ransom of 12,000 gold pieces, sent his staff back to negotiate the ransom, and kept him prisoner for about 40 days. They thought it amusing when he told them he would some day return, capture them, and crucify the whole lot. After the ransom was paid and he was released, he quickly gathered a fleet and chased after the pirates, caught them, and crucified all of them. Caesar later went on to conquer Gaul and become ruler of the Roman world, before ignoring warnings about the Ides of March and winding up the victim of assassination.

Are there pirates today?

Of course. They continue to exist today as they have for the past 2,000 years because of the drugs and liquor and other contraband that they can smuggle into many countries. Today the brigands have the aid of sophisticated technology and high-speed boats to run down slower vessels and escape pursuing patrols. And if the gamble is greater, what with the constant surveillance of planes and radar, the rewards are also greater if the pirates succeed in capturing a freighter or luxury yacht. One boatyard dealer said to us, "It's people like you and books like this one on pirates that give us a bad name." Probably true. But, unfortunately pirates still exist, and the wise mariner will take precautions.

FURTHER READING

James Burney, *History of the Buccaneers of America*. New York: Norton, 1950.

José Escofet, *Piracy and Pirates: A History*. London: Jarrolds, 1957.

A.O. Exquemelin, *The Buccaneers and Marooners of America*. Williamstown, Mass.: Corner House, 1976.

Henry Gilbert, *The Book of Pirates*. New York: Crescent Books, 1986.

Philip Gosse, *The History of Piracy*. New York: B. Franklin, 1968.

Philip Gosse, *The Pirates' Who's Who*. Boston: Charles E. Lauriat Company, 1924.

Captain Charles Johnson (alias of Daniel Defoe), *A General History of the Robberies and Murders of the Most Notorious Pyrates*. Columbia, S.C.: University of South Carolina Press, 1972.

Charles Kingsley, *Poems*. London: Macmillan and Co., 1902. pp. 290-91: "The Last Buccaneer."

James G. Lydon, *Pirates, Privateers, and Profits*. Upper Saddle River, N.J.: Gregg Press, 1970.

George Murphy, editor, *The Key West Reader*. Key West: Tortugas, Ltd., 1989, pp. 27-31: "Death of a Pirate" by John James Audubon.

The Pirates Own Book, or Authentic Narratives of the Lives, Exploits, and Executions of the Most Celebrated Sea Robbers. Portland: Sanborn & Carter, 1837.

Patrick Pringle, *Jolly Roger, The Story of the Great Age of Piracy*. New York: Norton, 1953.

Howard Pyle, *Howard Pyle's Book of Pirates*. New York: Harper, 1949.

A. Hyatt Verrill, *The Real Story of the Pirate*. Glorieta, N.M.: Rio Grande Press, Inc., 1989. This is a reprint of the 1923 edition.

C. Keith Wilbur, *Pirates & Patriots of the Revolution*. Chester, Conn.: The Globe Pequot Press, 1984.

Neville Williams, *Captains Outrageous: Seven Centuries of Piracy*. London: Barrie and Rockliff, 1961.

George Woodbury, *The Great Days of Piracy in the West Indies*. New York: Norton, 1951.

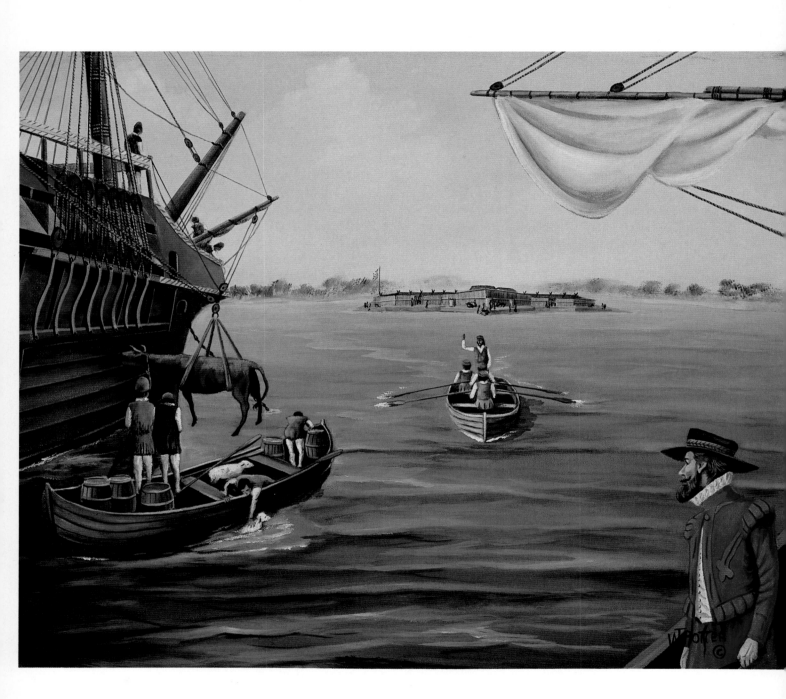

CHAPTER 1

\mathcal{S}IR JOHN HAWKINS, 1565

While pirates are generally known for their treacherous acts and disregard for others, occasionally some pirates performed deeds of kindness and humanity. One such pirate was John Hawkins, an Englishman whom the Spanish came to hate but whom the French had much reason to applaud for something he did in northern Florida in 1565.

Although too busy or skeptical to give Christopher Columbus any financial support to sail for the Indies, England's King Henry VII (king: 1485-1509) soon came to realize how lucrative the New World might be for his seafarers. His successor, King Henry VIII (king: 1509-1547), realized that England's future lay on the sea and therefore built a strong merchant marine and a navy to protect English interests. Among his seafarers was William Hawkins of Plymouth, who amassed a great fortune by smuggling slaves into the Spanish colonies of the New World.

His son John (1532-1595) continued his father's work and received much support from the new sovereign, Elizabeth I (queen: 1558-1603). The Protestant queen opposed Catholic Spain and wanted to take as much as possible of the enormous wealth that Spain was accumulating from its overseas empire. Known to the English as a privateer but to the Spanish as a pirate, Hawkins spent part of his early maritime career as a slave trader, capturing slaves in Africa and selling them to Spanish merchants in Europe and the West Indies in the 1560s. One of

his officers was a 22-year-old sailor from Devon, Francis Drake (more about him in the next chapter).

In July 1565, Hawkins was on a trip to the Caribbean selling slaves and searching for gold, silver, and pearls. On his way back to England, he sailed slowly up the Florida coast looking for fresh water supplies and possibly for a site where the English could establish a fort. From such a fort they could attack the Spanish treasure ships sailing up the coast on their return to Spain. The English realized that Florida might be good for cattle raising, but the lack of good rivers for harbors and the dangerous reef offshore discouraged them. The territory also did not seem to have much in the way of precious metals.

Observers on board the English ships noted two phenomena, one of which would have a lasting influence in Europe. First was that the Caribbean Indians of both sexes painted and tattooed their bodies with strange designs. That practice did not catch on with the English as much as the other one: tobacco smoking. The English noted how the local Indians (and the French who copied the Indians) smoked "a kind of herb dried" in a cane with an earthen cup at one end. The Indians lit the herb and sucked in the smoke, which seemed to satisfy their hunger and help their stomachs; the Frenchmen also took up the habit from the Indians. The pipe-smoking was in contrast to the cigar smoking that the Spanish had noted among the Indians in the Antilles. The English took back with them de-

tails of the tobacco smoking, and that helped introduce many Europeans to smoking.

On this particular trip Hawkins was also looking for a French settlement he knew was in north Florida. For help in finding the French, Hawkins had the services of a Frenchman who had been in Florida in 1562 with the French explorer Ribault. In the River of May (the present-day St. Johns) several miles away from the Atlantic Ocean, the guide helped Hawkins find the settlement, Fort Caroline, where the French Huguenots had established a colony. Its leader, René de Laudonnière, had been there with 200 soldiers without relief for over a year, since June 1564. Despite their high hopes of establishing a permanent foothold in the Florida territory, the French had not planned well. Instead of farmers, hunters, and fishermen, all of whom could have supplied food from the rich soil, woods, and waters, mostly soldiers were brought over, men who were unaccustomed and unwilling to till the soil, hunt in the nearby woods, or fish the river and ocean.

Instead, the soldiers opted for either becoming pirates themselves and attacking the Spanish in the Caribbean (at which they had limited success) or raiding Indian villages and stealing their provisions. The gold and silver which the French had hoped to find in Florida and which they did find on some Indians turned out to be not from nearby mines, but from loot that coastal Indians had taken from Spanish shipwrecks. The Indians, who at first seemed friendly and willing to help the French, resented the way the French plundered Indian villages and began to attack the unwelcome intruders.

When the Indians saw that the French armor protected the soldiers' bodies from arrows, the Indians aimed for their enemies' faces - with devastating results. The soldiers soon retreated to the safety of their fort, locked themselves in, and began grinding acorns and fish bones to make flour for bread. The Indians patiently waited outside, knowing full well that the Frenchmen could not survive for long without outside food.

When Hawkins showed up at Fort Caroline, many of the French soldiers welcomed him with open arms, arms that were in many cases just skin and bones from the lack of much food. They had been at their fort a year and were greatly disillusioned with the place. They hoped to return to Europe with

Hawkins and leave the Florida wilderness to the Indians. Hawkins was willing to help take the Frenchmen back to Europe, promising to take them to their native France before going to England. Taking them back would have pleased the Spanish king, Philip II, who might have forgiven Hawkins for the latter's attacks on Spanish settlements and might even have rewarded Hawkins financially, for example, with trading privileges in the West Indies. The English government also would have been pleased to have the French out of the Florida territory and might have rewarded Hawkins.

Laudonnière, however, was unwilling to entrust his fate and that of his colony to this Englishman. Laudonnière was unsure about the latest relationship between England and France and could not understand why Hawkins would transport the French to France. The French leader, besides suspecting that Hawkins might want to occupy Fort Caroline himself after the French left, also recognized the strategic importance of Florida and resolved to remain. He felt that a site like Fort Caroline could be very effective in intercepting the Spanish treasure fleet as it made its annual trip back to Europe full of gold and silver from Central and South America. The prevailing trade winds and ocean currents forced the Spanish ships to sail along the Florida coast rather than heading home eastward across the Atlantic. Confident of receiving supplies and new troops from relief ships sent out from France, he tried to convince his reluctant forces to remain with him.

What Laudonnière had come to realize was how important it would be for his troops to control the Bahama Channel off Florida. As Paul Hoffman pointed out in "The Narrow Waters Strategies of Pedro Menéndez," the French planned on taking a force of 800 soldiers to seize a port in the Florida Keys from which they could intercept all shipping passing north from Cuba. They would station six galleys offshore to stop and search ships, especially Spanish ones. If that plan were successful, the French then planned on capturing Havana and freeing the slaves there. The French would then build more forts from which they would attack Spanish settlements in Honduras and the Yucatán.

Hawkins had no desire to destroy the French fort, since the French soldiers presented no real threat to the English and might be useful in harass-

ing the Spanish, especially if the French were able to expand to the Florida Keys and raid Havana. Therefore, instead of destroying the French fort, he sold the soldiers a 50-ton ship, 20 barrels of meal, six pipes of beans, other food supplies, and even shoes for the soldiers (see picture). He never received full payment for those goods, although he apparently never expected to be fully paid. Giving so many of his scant supplies to the desperate French depleted his own food stock so much that he had to proceed to the Newfoundland Banks to catch cod for the return trip across the Atlantic.

Laudonnière expressed the feelings of many of his compatriots when he said that Hawkins "has won the reputation of a good and charitable man, deserving to be esteemed as much of us all as if he had saved all our lives." Had the French returned to Europe with Hawkins, they would have prevented a slaughter that the Spanish soon inflicted on them and might have changed the history of the area.

When the Spanish heard that the French had established a foothold in north Florida, they sent over a force under Pedro Menéndez de Avilés. With the help of a small hurricane that came up just as the French were about to attack St. Augustine, Menéndez killed the troops at Fort Caroline and slaughtered most of the others at Matanzas when they were shipwrecked below St. Augustine. If the French had not built Fort Caroline to begin with, the Spanish might not have established a fort at St. Augustine and might have been content to maintain only a small presence in Florida. Despite a retaliatory raid on the Spanish by the French in 1568, the destruction of the French troops by Menéndez effectively finished any French plans to establish a colony in Florida.

On that trip to the West Indies and Florida, Hawkins proved that English ships could make a profit by transporting animal hides to Europe, where merchants could sell them for a handsome profit. The pirate/privateer Hawkins showed that he had a kind side to him, and for that the French were grateful. The Spanish continued to regard him with suspicion if not hatred because of all the trouble he caused them. Hawkins had done his best to help the French remain in Florida, something which might have strengthened the power of France, but it was not to be.

In 1571, back in England, Hawkins became a member of the British Parliament and later treasurer and comptroller of the navy. He helped defeat the Spanish Armada in 1588, for which Queen Elizabeth I knighted him. In 1595, on an expedition to the West Indies with Francis Drake, he died and was buried at sea near Puerto Rico. As with so many seamen in maritime history, whether Hawkins was a pirate (as the Spanish believed) or a friend (as the French in Florida felt) or a hero (as the English called him) depended on who was doing the name-calling.

FURTHER READING:

John W. Cowart, "Praying Pirate Saved Fort Caroline." *Jacksonville Magazine* (Fall 1986), pp. 6-13.

Paul E. Hoffman, "The Narrow Waters Strategies of Pedro Menéndez." *Florida Historical Quarterly*, vol. 45 (July 1966): pp. 12-17.

Rayner Unwin, *The Defeat of John Hawkins*. New York: Macmillan, 1960.

Neville Williams, *The Sea Dogs: Privateers, Plunder and Piracy in the Elizabethan Age*. New York: Macmillan, 1975.

James A. Williamson, *Hawkins of Plymouth*. London: Adam and Charles Black, 1949.

James A. Williamson, *Sir John Hawkins*. Oxford: Clarendon Press, 1927.

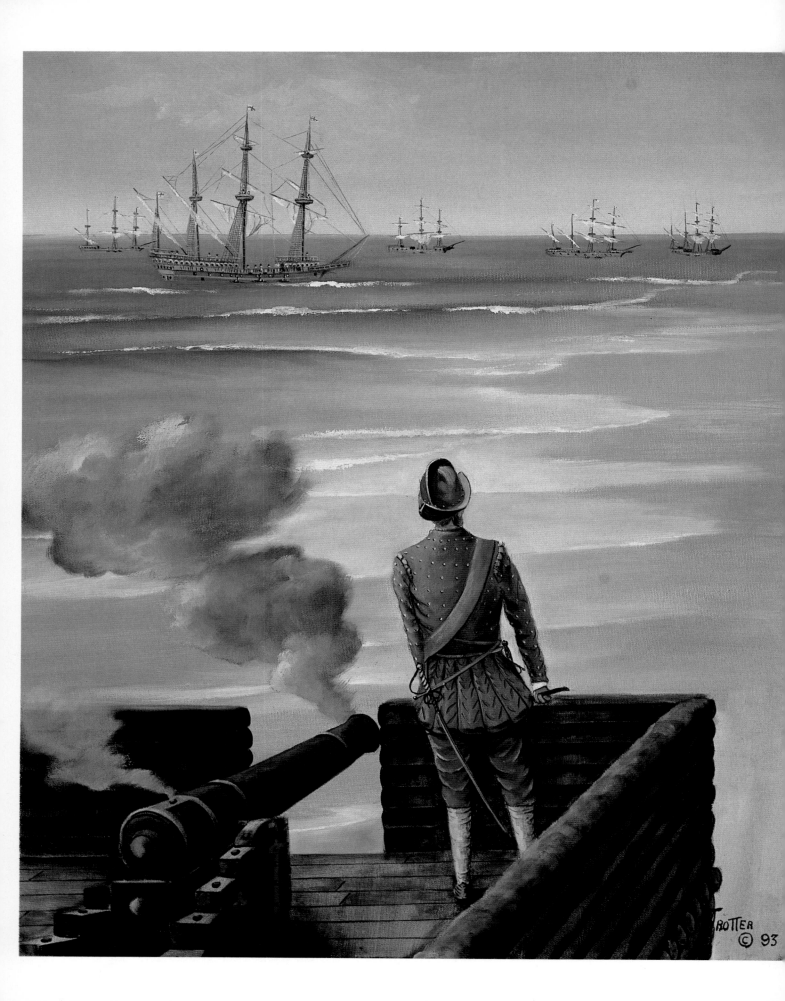

CHAPTER 2

\mathcal{S}IR FRANCIS DRAKE, 1586

In the days before stately lighthouses dotted Florida's coast to warn sailors offshore of nearby reefs and dangers, the Spanish used simple towers from which sentries could scan the ocean and warn residents on land of approaching danger. Sixteenth-century Spanish settlers in the new town of St. Augustine (or San Agustín as the Spanish called it) erected such a tower on Anastasia Island. When sentries in that tower spotted a ship in the distance, they would strain to make out its shape and flag. If they determined that the ship posed a danger to the inhabitants of the city, they would signal to the settlers, who would flee to the safety of their new fort or to the surrounding woods. In one disastrous case, the sighting of that tower from the sea led to the sacking of the town.

After Columbus landed in the New World in 1492, the Spanish claimed all Caribbean lands, in fact, all of the Western Hemisphere. The Portuguese did not accept this grandiose scheme and claimed a sizable portion after Pedro Alvares Cabral visited Brazil in 1500. Spain and Portugal argued over who controlled what and finally allowed the Pope in 1493 to draw a line that gave Brazil to Portugal and much of the rest of the hemisphere to Spain.

France and England did not like that arrangement and made plans to establish their own colonies in the New World. They soon learned that making claims to the new land was relatively easy; defending those claims was much harder and entailed the commitment of many resources at a time when European wars were draining more and more of those resources.

The rivalries among the European countries in the New World were political, financial, and religious. Those countries in Europe that were fighting each other in wars, wars that were often caused by political disputes, found themselves fighting those same rivals on the high seas and in the New World. The financial aspect revolved around the immense wealth that Spanish and Portuguese galleons were hauling back to Europe from the silver and gold mines of the New World. That wealth enabled Spain and Portugal to become more powerful nations than their size might dictate. The religious rivalries revolved around the Catholicism of Spain and Portugal versus the Protestantism of France and England.

English commanders like Sir John Hawkins, Sir Francis Drake, and Sir Richard Grenville wreaked havoc on the Spanish ships and settlements in the New World throughout the 16th century. The Spanish called them pirates, but the English had another name for them: privateers. Whether someone was a pirate or a privateer depended on who was doing the name-calling. The word "pirate" comes from a Greek word, *peiran*, which means "to attack" and was used for any brigand who illegally attacked ships, including those of his own nation. The English word also comes from Latin *pirata*, "one who plunders or robs on the sea." Nations used the term "pirate" for someone from another nation who attacked their ships.

A privateer, on the other hand, was someone who had official papers from his government that allowed him to attack and capture enemy ships. The official papers, called letters of marque, allowed the privateers to take their pay from the cargo they captured. The more honest privateers set aside a certain percentage of the spoils for their king, but even if they did not, they often did so much damage to enemy shipping and so tied up enemy fleets that the official sponsors of the privateers were really pleased at their attacks on the enemy. The word "corsairs" was used for the pirates of the Barbary States who had their headquarters in Algiers and other North African ports. (See Chapter 11 for information on buccaneers.)

The Spanish galleons, which brought much-needed workers, officials, and supplies to settlements in South America and Florida and then returned to Europe with gold and silver in the 16th century, were no match for the speedy English ships. Even the presence of Spanish men-of-war to protect the lumbering galleons could not fend off the pirates/privateers. When the treasure fleet set sail from Havana, Cuba, up along the Florida Keys and east coast, through the Atlantic to Spain, pirates and privateers waited for those galleons and hoped that a quick strike would isolate the slower ships and lead to the capture of immense wealth.

Francis Drake (1540?-1596) was from Devonshire, England, the son of a yeoman. At an early age he went to sea as an apprentice to a captain. There he learned the art of seamanship, engaged in the slave trade, and became skilled at attacking ships of all sizes. His fellow Englishmen called him Admiral and the Prince of Privateers, whereas the Spanish called him The Dragon and considered him one of the most dangerous pirates on the high seas. He had sailed to the New World with Sir John Hawkins in 1567 as a 22-year-old captain of his own vessel, the *Judith*. That trip ended badly as the Spanish almost captured Hawkins and Drake.

The Dragon would return to haunt the Spanish until he died. The author of *Piracy Was a Business* stated that among all the English pirates, "Drake, who was the most destructive, was not wantonly cruel but he had no respect for human life nor for property rights when they stood in the way of his twofold object of enriching himself and weakening the na-

tional enemy." (p. 42)

In 1572, Drake sailed to Panama and captured from the Spanish 30 tons of silver ingots, which he brought back to England in triumph. Eight years later, he became the second man to sail around the world, for which feat Queen Elizabeth I knighted him aboard his famous ship, the *Golden Hind*. On that circumnavigation of the globe he had attacked Spanish settlements and ships on the Pacific coast of South America. By honoring Drake for attacking the Spanish on both the Atlantic and Pacific and adding Spanish wealth to the English treasury, Queen Elizabeth was encouraging other young English seamen to become privateers/pirates.

In 1585, he set out with a large fleet of some 25 ships and 2,300 men to cross the Atlantic and attack Spanish ports, hoping to weaken England's rival and cut off her supply of gold and silver. He attacked and subdued Santo Domingo in the present-day Dominican Republic and then the port of Cartagena in Colombia. On the way back to England, he sailed slowly along the coast, looking for any Spanish fort from which the Spanish could send ships and troops to attack Sir Walter Raleigh's English settlement at Roanoke, Virginia.

Drake had with him a Portuguese pilot who willingly helped the English because of the Portuguese dislike of the Spanish. That man told Drake that the Spanish had established a fort at St. Augustine near where they had slaughtered the French in 1565, first in their fort at Fort Caroline in the St. Johns River and then at Matanzas below St. Augustine after the French ship *Trinité* had shipwrecked along the coast during a storm.

Drake and his men had their first clue to the location of St. Augustine when they spied a beacon tower standing tall on four masts on the beach on Anastasia Island. Drake landed with his men and marched along the river that led to the town. Three of his men boarded a small rowing skiff and scouted the area, but could not find any Spaniards. Then they heard something that at first completely unnerved them, but then gave them great hope: a fifer playing a tune that everyone in those days recognized as a very anti-Spanish tune. If the men could find the person playing that fife, they knew they would find someone who might hate the Spanish as much as they did.

The fifer turned out to be Nicholas Borgoignon, a Frenchman who had been a prisoner of the Spanish for six years but who had recently escaped. With his help, Drake and his troops found St. Augustine and made plans to sack it. They found the newly built fort that consisted of huge, upright tree trunks (see picture). On top was a platform with 14 brass cannon standing side by side. They also found a chest full of the garrison's pay, worth about 2,000 English pounds. Nowhere in sight were any of the 150 soldiers who were supposed to be defending the fort. Nor were there any townspeople in the small town that had grown up near the fort. In their haste to flee the English, the Spanish actually left behind in the fort a small child. The English handed the child over to the Spanish, unwilling to ransom her or take her back to England.

The quiet of the fort was suddenly broken with sniper shots fired by the Spanish from nearby trees. Anthony Powell, who was second in command of the English infantry, found a Spanish horse already saddled and rode off in pursuit of the snipers. The Spanish marksmen took aim and shot him down. When he fell, the Spanish descended on him and finished him off with several sword thrusts before the English troops could reach him. Drake would not allow any more of his men to seek out the hiding Spanish, but instead had his troops destroy the fort and the settlement after gathering those tools and implements which Drake could take to English colonists up the coast in Virginia. He also took a dozen cannons. Drake did not have his troops destroy the nearby Indian village, perhaps on the chance that the Indians might aid the English in the future.

The sacking of St. Augustine pointed out to the Spanish how weak their New World settlements were and how formidable the English were becoming. The latter became very clear two years later when Drake helped lead the English fleet in a great victory over the Spanish Armada. The fact that many of Drake's seamen at the battle with the Spanish Armada had served in the New World as pirates (according to the Spanish) or privateers (according to the English) made them skilled at handling ships during enemy attack.

When Drake died eight years later of a fever in the Caribbean and was buried at sea, the Spanish had to be grateful that he would no longer be around to harass them. The Dragon, the man the Spanish considered one of the most despised pirates, was finally silenced.

FURTHER READING:

Kenneth R. Andrews, *Drake's Voyages*. New York: Charles Scribner's Sons, 1967.

Cyrus H. Karraker, *Piracy Was a Business*. Rindge, NH: Richard R. Smith Publisher, Inc., 1953.

Mary Frear Keeler, editor, *Sir Francis Drake's West Indian Voyage, 1585-86*. London: Hakluyt Society, 1981.

Albert C. Manucy, "2. Enter the English," in *The History of Castillo de San Marcos & Fort Matanzas From Contemporary Narratives and Letters*. Washington, DC: U.S. Department of the Interior, 1955, pp. 6-10.

Kevin M. McCarthy, "*Trinité*, 1565," in *Thirty Florida Shipwrecks*. Sarasota, FL.: Pineapple Press, 1992, pp. 12-15.

George Malcolm Thomson, *Sir Francis Drake*. New York: William Morrow, 1972.

James A. Williamson, *Sir Francis Drake*. London: Collins, St. James Place, 1951.

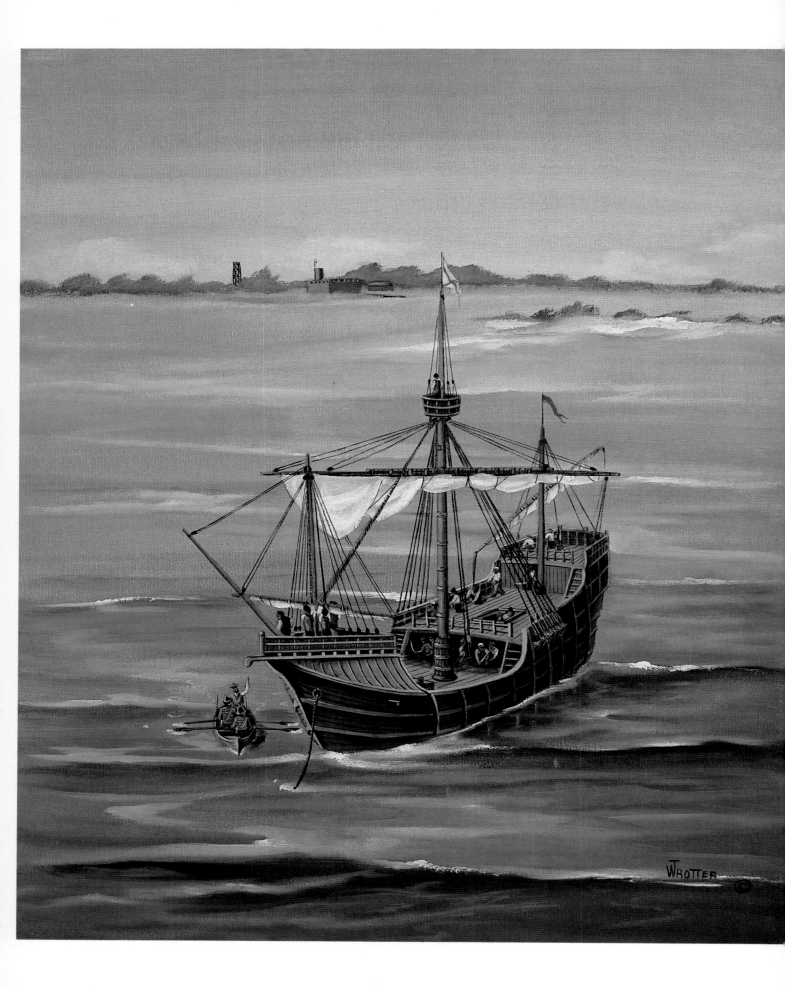

CHAPTER 3

ROBERT SEARLES, 1668

Pirates were not fools. Instead of attacking a fortified site directly and risking their lives and ships, they preferred deception, ruses — anything that would lessen the risk, but still ensure success. Such was the case in May 1668, when an English pirate approached St. Augustine with the intention of sacking the Florida town.

The beginning of the attack actually began far away, off the coast of Cuba. There Robert Searles, alias John Davis, captured a Spanish supply ship and a brigantine; the supply ship was on its way from Vera Cruz, Mexico, to Florida, bringing supplies like flour, and the brigantine was heading for Havana. On board the frigate was a French surgeon, Pedro Piques, who had been working at the St. Augustine presidio. Apparently the Spanish governor in St. Augustine had had an argument with Piques, during which he had slapped the Frenchman and dismissed him. When Searles captured the frigate and discovered the Frenchman, the doctor must have told the pirate about the vulnerability of St. Augustine and suggested ways of attacking the fort.

Searles realized that the Frenchman's desire for revenge against the Spanish played right into his own plans, and began thinking of ways to attack the outpost. He then sailed with the two captured ships to St. Augustine, kept his own warship and one of the captured ships out of sight, and sailed into view of the fort with the Spanish ship that the people of St. Augustine were expecting. He made the Spanish crew of the captured ship appear on the deck and perform their usual tasks as if nothing were wrong.

The pirate signaled for the harbor launch to come out with the master pilot. When the pilot and his crew approached the Spanish ship, the pilot called out to the Spanish seamen and asked where they were from and what they were bringing. The Spanish seamen, mindful of the pirate guns trained on their backs by the concealed pirates, answered that they were bringing supplies from Mexico for the town (see picture). The harbor pilot had a crewman fire two shots as a signal to the soldiers back on land that all was well, that the ship was friendly. When the pilot and his men boarded the ship for what they thought would be a routine entrance into the St. Augustine inlet, the pirates captured him and his crew.

When the soldiers and townspeople of St. Augustine heard the reassuring shots from the pilot of the harbor launch, they relaxed, put away their guns, and went about their business. They surmised that the Spanish ship at the entrance to the inlet was merely waiting for a favorable wind before coming up to the town. The Spanish townspeople, suspecting nothing out of the ordinary, retired for the night, confident that the supply ship would dock in the morning and bring them some much-needed supplies.

Around midnight, when the townspeople were asleep and the tide was high, Searles led his men and the captured ship into the harbor, past the guns of the fort that could have caused so much damage

if only the guards had known that pirates were on the ship. A soldier from the fort was out on the water fishing when he heard the unexpected sound of four boatloads of men paddling for the sleeping town. When he realized that the enemy was about to attack, the soldier dropped his fishing gear and quickly made for shore. The pirates heard him, realized he would arouse the sleeping town, and chased after him, firing their guns at the distant figure. The soldier, despite having been wounded twice, made it to shore and ran to the fort, where he roused the sleeping garrison.

When the pirates landed, they quickly spread out, killing or capturing anyone they found and pillaging the homes and stores. Suddenly aroused out of their peaceful sleep by the shouts of the pirates and their victims, the townspeople fled their homes, heading for either the fort or the surrounding woods. Many made it to safety, but feared that a sustained attack on their little fort would level it.

Searles and his men paused in their looting and aimed their guns on the fort. But once again, as so many attackers had found out and would discover in the future, the castillo's walls were too thick for anything but powerful siege guns, which Searles did not have. Realizing the futility of attacking the fort without more powerful guns and siege equipment, the pirates returned to their looting of government buildings and private homes. The brigands removed or destroyed whatever they found, even going into the church and little monastery to take everything they could carry.

In the end, some 60 Spaniards, nearly one-fourth of the total Spanish population of Florida, died in the attack. What also worried the survivors was the fact that the pirates took soundings in the harbor, clearly a precursor to returning to the little settlement to take permanent control of the area. That fear was increased when the Spaniards, upon leaving the fort and returning to their homes, realized that the pirates had not destroyed the government buildings or homes, something they easily could have done. All the signs pointed to the fact that the pirates were planning on returning for permanent settlement.

When the pirates left, they took with them Dr. Henry Woodward, whom the Spanish had captured several months before and had taken to St. August-

ine. Dr. Woodward had been a strange prisoner in the little town. By his charm and personality he had ingratiated himself into the confidence of the Spanish townspeople and had slowly come to know the little settlement very well. The people could not understand why the doctor had been so inquisitive about the town, its people, its defenses.

The Spanish authorities, who did not consider the young doctor a threat, had allowed him to wander the town's streets and become quite friendly with the people. Little did they know how much he was learning about the town's defenses and about the trade the Spanish were conducting with the Indians. When Woodward left with Searles, he eventually made his way to Charleston, South Carolina. There he helped the Carolinians develop a strong trade with the Indians, having learned much from what the Spanish had done in north Florida.

Before the pirates left the inlet, they ransomed their Spanish prisoners, about 70 men, women, and children, for firewood, meat, and water. It was those ransomed Spanish, who had witnessed the soundings that the English pirates had taken of the harbor, who informed the townspeople that the pirates intended to return to establish a permanent settlement. From such a base, the pirates could swoop out on ships passing along the coast and wreak havoc on the shipping lanes. The pirates did not return the Indians they had captured in the raid, but instead took them away, intending to make them slaves.

The pirates had no love for the Spanish and knew what their own fate would be if the Spanish were to capture them. Whenever the Spanish captured Englishmen on Florida soil, even if the Englishmen were shipwrecked sailors, they would sentence them to work the Spanish galleys. One time, when the Spanish captured some Englishmen near St. Augustine, the Spanish insisted that the English convert to Catholicism and then hanged them. At least, so the Spanish reasoned, the Englishmen wound up in the right religion and might be saved in the next life.

The results of the pirate attack on St. Augustine were many. For the residents of the town, the situation looked bleak. The killing of the soldiers by the pirates, as well as the destruction or theft of the town's weapons, diminished the ability of the Spanish to defend themselves. The loss of the flour from Mexico in the captured ship and the food given to

the pirates to ransom the prisoners seriously depleted the town's meager food supplies. The poor maize crops, hurt by a continuing drought, offered little relief.

It would take more than three months for the people in St. Augustine to notify authorities in Havana of the pirate attack. It took so long because of the lack of any decent ships to use on the high seas. It would take another three months, six months in all, before the monarch in Spain learned of the pirate attack. Some of the survivors in Florida must have questioned the wisdom of staying in such a dangerous place.

The pirates quickly realized how vulnerable the north Florida outpost was and may have considered a permanent settlement there, as they led the Spanish to believe. From St. Augustine the pirates would be able to dash out to attack the Spanish galleons returning to Spain with treasures from South America and Mexico.

For their part, the Spanish monarchs realized more than ever how vulnerable their north Florida site was, but were unable to supply the settlement with the vast sums needed to upgrade the fort and settle more residents there. The European threats to Spanish rule demanded that the Spanish monarchs direct most of their resources closer to home. When other Spanish settlements in the Caribbean learned of the pirate attack on St. Augustine, they feared for their own safety and demanded more money and forces from a Spanish monarch who could not supply them.

Rumors spread about the pirates' plan to establish a permanent settlement in Florida, but the settlements' demands to the Spanish crown to send more resources fell on deaf ears. Mexican-born soldiers were reluctant to sign up for service in Florida, which they considered inhospitable and dangerous. The Spanish monarch realized that Florida did not have the gold and silver and natural resources that early explorers had searched for, but it did have a strategic position that could protect the sea lanes as Spanish treasure ships returned to Spain.

So much time elapsed between the 1668 pirate raid and the sending of adequate supplies from Spain that the English were able to establish a permanent colony in Charleston, something they might not have been able to do had the Spanish fortified their north Florida fort and launched efforts to thwart the English. Part of the delay in sending supplies to St. Augustine was caused by a rumor spread by Indians along the east coast of Florida that the English had attacked and destroyed the town. What started the rumor was a boast by someone on an English ship that an English fleet was heading for St. Augustine. The Indians spread the rumor that the fleet was on its way and had actually destroyed the town, when in fact nothing like that had happened. But the rumor effectively discouraged the Spanish from sending any supplies there until they could see for themselves what the situation was.

When the Spanish finally decided to strengthen St. Augustine to prevent further pirate attacks, local authorities convinced their superiors to build a massive stone fort, the Castillo de San Marcos. Several years passed while the Spanish made their plans and raised enough money. Finally, in 1672, workers began building the Castillo. They used the coquina from nearby pits and converted thousands of oyster shells in the area into lime for use in the fort. How well that fort would stand up to another pirate attack would become clear 11 years later (see Chapter 5).

FURTHER READING:

"Aid to St. Augustine After the Pirate Attack, 1668-1670," *El Escribano* (July 1970), pp. 74-93.

Luis Rafael Arana and Albert Manucy, *The Building of Castillo de San Marcos.* St. Augustine: Eastern National Park & Monument Association for Castillo de San Marcos National Monument, 1977.

Verne E. Chatelain, *The Defenses of Spanish Florida, 1565 to 1763.* Washington, D.C.: Carnegie Institution of Washington, 1941.

Michael V. Gannon, "Carry Me Back to Old La Florida," *The Virginia Magazine of History and Biography* (January 1985), pp. 79-92.

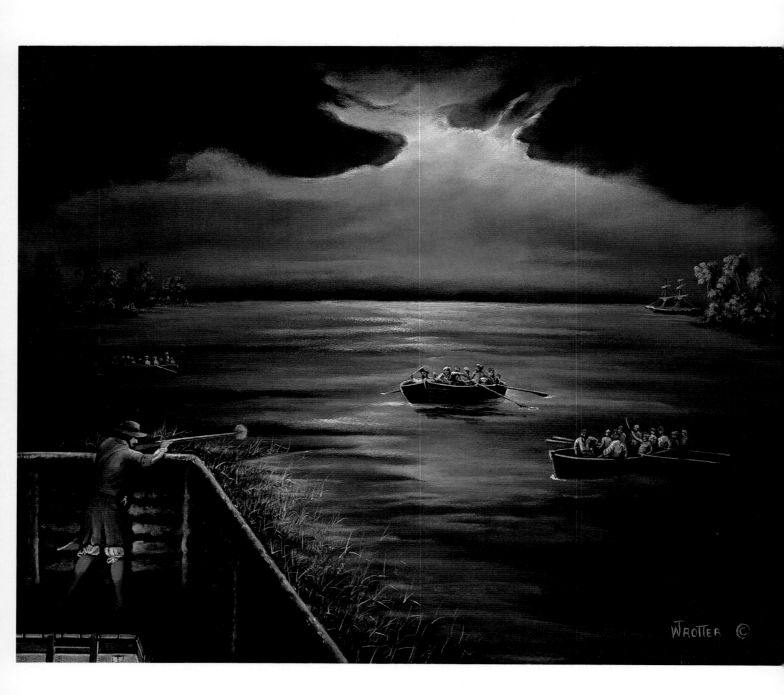

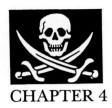

CHAPTER 4

THE SAN MARCOS PIRATES, 1682

Visitors standing at the junction of the St. Marks River and the Wakulla River some nine miles from the Gulf of Mexico can quickly understand how strategic the fort there was. It could control both waterways, but still allow the inhabitants to flee inland in the face of invaders from the Gulf. Today, visitors to the museum there can see from the huge painting on one of the inside walls what the situation was like in the late 17th century when pirates attacked the small wooden fort on an island in the rivers.

The St. Marks River from the Gulf of Mexico up into the belly of Florida's Panhandle was a vital waterway recognized by the Spanish authorities in charge of controlling the territory. The Spanish had first come to the area in 1528, when explorer Pánfilo de Narváez arrived from Tampa on an overland march with 300 men. They built and launched what historians call the first ships made by white men in the New World. In the 17th century, the local Indians were able to grow rich yields of maize, wheat, tobacco, and cotton, crops that would supply the Spanish with much-needed supplies over the years. Nine miles up the river from the Gulf of Mexico lay a small harbor that the Spanish considered vital for protecting the inland water route.

The Spanish had begun converting the Indians in Apalache in 1633, but had found it difficult and time-consuming to supply the missions overland from St. Augustine. The 200-mile land trip on which the Spanish used Indian porters seemed to be the only way to take supplies to the missions unless the Spanish could establish a harbor in the St. Marks River. In 1637, the Spanish governor had two seamen chart and mark the river with the intention of establishing a harbor there.

One of the seamen later sailed from Havana to the St. Marks River in one week, bringing with him supplies for the missions and the hope of finally having regular service between Cuba and the Florida outpost there. In 1639, the Spanish opened a sea route between the river and St. Augustine and began taking corn from the Apalache Province on a two-week sea voyage to the troops in northeastern Florida. Ships also began transporting corn, beans, pigs, chickens, turkeys, deerskins, and other agricultural products from the rich Apalache Province to Cuba for the people of Havana and the fleets of the Indies.

Spanish authorities in Cuba and Spain suspected that the locals in San Marcos, whether officials, soldiers, or friars, welcomed foreign ships to their port. In exchange for money or much-needed supplies, the locals would supply the foreigners with food and water, allow them to escape a storm on the Gulf, help them careen their vessels, and even supply them with crew members. All of that was forbidden by Spanish authorities.

But even though officials in Cuba and Spain outlawed what they saw as collusion between the locals and the foreigners, businessmen on the scene ignored the prohibition and continued doing busi-

ness with anyone who arrived, whether Dutch or French or English, legitimate traders or friendly pirates. If the locals would not agree to stop offering refuge to the foreign ships, the Spanish would have to station troops in all the ports and forts. Isolated ports like San Marcos proved especially troublesome because of the vulnerability of the outposts to pirate attacks, as happened in 1677.

In that year, a group of French and English pirates sailed into the St. Marks River and captured a Spanish frigate full of deerskins and food supplies. In the nearby warehouse, they seized more supplies and a sea chest full of valuable ambergris, a wax-like substance used in making perfume. The pirates took three prisoners, not with the intention of killing them, but merely to ransom them, a common practice in the Caribbean and Gulf. The Franciscans stationed in the fort obliged the pirates by exchanging 30 hogs for the prisoners.

Realizing how vulnerable the local Indian tribes and settlers were to pirate attacks up the St. Marks, Spanish authorities debated asking the Indians to move further inland. Authorities pointed out that pirates often captured local Indians along the Florida coast and forced them to act as guides for the rivers and channels of the Gulf. When the Indians objected to moving inland, the Spanish decided to build a small fort to protect them. They contracted with the Apalaches to build the fort on the small piece of land where the St. Marks joins the Wakulla River and called it the castillo of San Marcos de Apalache.

The Indians built the small, 67-foot-square stockade using logs cut from palm trees. They whitewashed the logs with lime to make them look like the more formidable masonry and stone of bigger forts. A shallow moat that the river flushed out at high tide offered additional security. The area would flood during storms, but soldiers could temporarily leave the island at such times. A mile north of the fort was the small settlement of San Marcos, with a warehouse and some huts. The Spanish governor also suggested that workers build a watchtower on the Gulf itself and man it with two soldiers and two Indians who could spot any intruders and warn the castillo, but workers had not begun it yet when another pirate attack occurred.

In March 1682, French pirates in the Gulf of Mexico spotted a two-masted, flat-bottomed vessel just arriving at San Marcos from Havana. Suspecting that it or the warehouse it was heading for would contain a good supply of provisions and other booty, the pirates waited for darkness and followed the vessel up the river. When they came closer, 66 of the pirates went from their frigate into three fast, light boats and continued up the St. Marks on the rising tide.

Around midnight they reached the fort, whose white walls and gun emplacements the pirates could just make out by the light of the moon. When the guard on duty that night spotted the three boats in the river, he quickly roused his superior, who shouted out in Spanish, "Who goes there?" to the boats in the water and, when he received no answer, fired his musket. Someone shouted, "To arms! To arms! The enemy is in the port!" Soldiers rushed to their posts and made ready to defend the fort. Meanwhile, the pirates had formed two groups, one heading for the fort and the other for the warehouse.

As dawn came, the pirates around the fort realized that the structure was made of wood, not stone, and decided to burn it down. When the friars on the wall of the fort heard that the pirates were going to burn the fort down, they pleaded for mercy from the brigands and begged them not to kill those inside. The Spanish in the fort decided to give up rather than try to ward off the pirates, opened up the fort, and lowered the drawbridge for the invaders. Later, in an investigation of who was to blame for the loss of the fort, the Spanish commander blamed the capitulation on the unwillingness of the friars to resist and their opening of the fort's doors to the pirates.

Before all of the Spanish could escape to the interior of the countryside, the pirates captured 13 of them. The prisoners, however, did not fear for their lives, having learned from experience that the pirates would probably not kill them. Those who could afford the ransom would pay it and be set free. The poorer prisoners would have to work for the pirates for a year or so, but then they, too, would be released. In this way the pirates could earn more money from the attack, acquire some laborers for their ships, and maybe even replenish their forces with captives who were willing to give up their poorly paid though safe positions for the exciting though dangerous life of a pirate.

The pirates loaded onto their boats the large amounts of corn they found in the warehouse, as well as any guns and ammunition they could discover. They destroyed the muskets and other weapons of the Spanish, demolished part of the fort, and retreated to their frigate down the channel. Neither side had any fatalities or serious injuries, and the fort, while badly damaged, could be repaired.

Meanwhile, the pirate captain began to see if he could ransom his captives as was his custom. He was willing to accept the usual amount for a group of prisoners: ten hogs. He released six of his 13 captives to return to San Marcos to tell the authorities of his demand for ransom, but this time the Spanish refused to pay up.

The pirates increased their pressure by bringing in another frigate and making as if they would reoccupy San Marcos, which the Spanish were repairing. When the pirates sailed into the port in broad daylight and made ready to fire on the fort, the Spanish commander ordered the men who were repairing the fort to stop their work and, in fact, to tear the fort down so as to prevent the pirates from using it. Before leaving the area to the pirates, the Spanish burned down the warehouse and other buildings and then retreated into the surrounding woods.

The pirates by this time were becoming exasperated with the failure of the Spanish to come up with the ransom and made new threats that they would proceed inland and kill whomever they found. The Spanish still refused to give in to the pirates and, instead, positioned soldiers and some 200 Indians to defend access roads to the interior.

Finally, the exasperated pirates made their move. They sent landing parties up the rivers on either side in a clever move to surround the enemy in a pincer-like maneuver. When the Apalaches realized that the pirates could easily get behind the front lines and meet and trap them, they quickly decided that running away was far better than being captured and sold as slaves or pressed into service on the pirates'

ships. When the Spanish soldiers saw the Indians fleeing, they, too, panicked and began to run from what seemed like certain capture. When their commander tried to stop them, they pushed him into the river and continued running. They had a 21-mile flight ahead of them, but that was better than fighting the heavily armed pirates.

When the pursued looked behind them to see where the pursuers were, they found no one chasing them. The pirates were content to ransack the port and capture anyone left behind, but did not want to risk their lives simply to prove a point or punish the Spanish. After finishing their assault on the fort, the pirates headed south to their base of operations at Anclote Key on the west coast of Florida above present-day Tampa. Spanish authorities needed someone to discipline over the successful pirate raid and chose the commander of the San Marcos fort, who was arrested, court-martialed, and banished. Others were just as guilty as he was, if not more so, but he became the scapegoat for the fiasco.

The pirate raid on San Marcos showed once again how vulnerable small outposts were. The Spanish would do well to concentrate on larger, more strategically located sites like the castillo in St. Augustine, although the pirates were sometimes bold enough to attack those places. In 1718, the Spanish rebuilt the fort at San Marcos, but used wood again for the structure. Twenty-one years later they began the first stone fort there. William Augustus Bowles would later capture that fort for a short time (see Chapter 12).

FURTHER READING:

Mark F. Boyd, "The Fortifications at San Marcos de Apalache." *Florida Historical Quarterly* (July 1936), pp. 3-34.

Amy Turner Bushnell, "How to Fight a Pirate: Provincials, Royalists, and the Defense of Minor Ports During the Age of Buccaneers." *Gulf Coast Historical Review* (spring 1990), pp. 18-35.

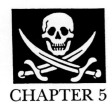

CHAPTER 5

\mathcal{T}HE ST. AUGUSTINE PIRATES, 1683

The 1680s were difficult times for the Spanish in Florida. As we saw in the last chapter, pirates attacked the small fort at San Marcos de Apalache in 1682 and did much damage. They also attacked ships in the Bahama Channel off Florida and inflicted damage at Mosquito Inlet south of St. Augustine. Officials in St. Augustine were worried; they knew they had to hurry to finish the Castillo de San Marcos in order to be able to defend the town, but work was proceeding slowly. The Spanish governor asked local church officials for permission to have the workers work on holy days, but the church officials refused, partly because they did not like the governor. When he appealed to higher church officials, they eventually agreed, but allowed him to do so only in emergencies. He hoped that workers could finish the building of the fort before the expected attack by pirates, but it was not to be.

The Spanish governor learned from various sources that the pirates would soon attack his town. Spanish authorities in Cuba had captured a group of pirates who had come from the Bahamas to salvage a sunken Spanish ship near Havana. The captured pirates admitted that they had plans to go on to Florida after the salvaging of the Spanish ship and were going to attack the fort in St. Augustine. To guide them along the Florida coast and into the inlet off St. Augustine, the pirates had found Alonso de Avecilla, a man who had been born in St. Augustine and knew the area well. When Avecilla learned of the pirates' intent to use him, he fled to the home

of a Quaker in the Bahamas, expecting to use it as a refuge from the pirates, but the pirates convinced the local governor to allow them to seize Avecilla, and they then proceeded on their way.

The pirates had planned to sail to Florida in one large ship and several smaller vessels. When they arrived at a point far below the town, they would transfer to the smaller vessels. When they reached a point about 40 miles south of St. Augustine, they would once again go into smaller boats, called pirogues. When they came within 15 miles of the Matanzas Inlet, they would land and march up the coast to the watchtower. Then, if all went according to plan, they would use their pirogues to go up the Matanzas River to St. Augustine. After they sacked the town, they would transfer the loot to the larger vessels, which would have sailed to St. Augustine Inlet and waited offshore.

Because of the seriousness of the pirates' would-be attack on St. Augustine, once the Cuban officials discovered the plan, they sent a warning to St. Augustine by three different routes: via the Spanish fort at San Marcos de Apalache in the Florida Panhandle; via La Chua Ranch west of St. Augustine; and via the Ays Indians south of Cape Canaveral. The Spanish governor at St. Augustine, Juan Márquez Cabrera, also heard the rumor of an attack from the captain of a Dutch ship that docked at the town. The Spanish there definitely knew of the impending attack and made plans for defending the town; for example, building two watchtowers: one

above the town and one about 21 miles below Matanzas.

On March 29, 1683, the pirates approached Matanzas Inlet south of St. Augustine. The small Spanish outpost there on the southern tip of Anastasia Island was meant to guard the Matanzas River, which provided easier access to St. Augustine than the inlet opposite the town. The sentries in the watchtower trained their eyes toward the sea and the inlet, knowing full well that any invaders would come from that direction.

At high tide the pirogues took some of the pirates silently and quickly under cover of darkness up the river beyond the watchtower (see picture). The men then went ashore and crept close to the watchtower, concealing themselves behind the sand dunes. As the sun came up on March 30th, the pirates rushed toward the watchtower and caught the five sentries, who were asleep, completely by surprise. The pirates then went to the inlet and ferried over the rest of their comrades, who had been waiting out of sight south of the inlet. The pirates forced one of the Spanish sentries to lead them north on the Matanzas River toward St. Augustine, but he deliberately got them lost up one of the small creeks leading into the river, and that further slowed the attackers' march on the town.

The pirates' plan to march quietly and unobserved toward the small town was thwarted when a Spanish soldier, who was passing near Matanzas, spotted the pirates and barely made it to safety by swimming across the inland waterway to the mainland. He was then able to make his way north to St. Augustine to warn the governor. The soldiers at the watchtower 21 miles south of Matanzas Inlet also discovered the pirates, who were heading north along the beach; they escaped by heading west to the mainland. On the way to St. Augustine, the Spanish soldiers met a man on horseback and convinced him to ride quickly to the town to warn the governor of the pirates' landing.

By late afternoon of the 30th, the governor and townspeople knew of the impending attack and made plans to defend the town. Military officials ordered to the fort the soldiers in the area, as well as the families of the soldiers, even though the incomplete fortifications would not protect them very well. Workers had still not built quarters, ovens, mills, or wells. The governor then sent a band of soldiers along Anastasia Island to try to ambush the pirates if they headed up the island.

The governor, in his haste to make the Castillo as formidable as possible in a short time, resorted to cursing the workers, soldiers, and anyone else in the vicinity, including the priests. One official, reporting later about the pirate attack, felt that the cursing was so vile that he could not even mention the offending words in his report. If it had not been for the calming words of the fort's chaplain, the soldiers might have staged a small mutiny. Order returned only when the soldiers learned from scouts that the pirates were approaching the Castillo.

The Spanish, expecting maybe four dozen pirates, lay in wait for them just a mile or so southeast of the Castillo. Having reached a strength of over 200 men, the pirates did not suspect anything and walked right into the ambush. After a fierce exchange of gunfire the pirates retreated down the island, but captured a Spanish soldier, Francisco Ruiz, on their way. Before deciding whether to attack the Castillo or abandon what was becoming a costly sortie, the pirates tortured Ruiz in a useless effort to force him to reveal any weakness of the Castillo. But Ruiz told them that the fort was becoming stronger each hour and that the Spanish could be expected to post soldiers all along Anastasia Island to ambush them.

When the pirates threatened to kill Alonso de Avecilla, the St. Augustine native they had captured in the Bahamas to lead them to St. Augustine, because he had not told them of the watchtower below Matanzas Inlet, Ruiz interceded. He told them that Avecilla could not have known about the watchtower since the Spanish had built it after Avecilla had left the area. The pirates then realized that they had lost the element of surprise, that the Spanish might be waiting for them along the way, and that Ruiz might be right about the strengthening of the Castillo. They prudently decided to retreat to their ships at Matanzas.

The Spanish probably should have attacked the pirates more aggressively at nighttime, both by land and by sea, but the size of the enemy force surprised them and convinced them to withdraw to the safety of the Castillo in St. Augustine. A Spanish attack, especially if it had succeeded in capturing the pirates' pirogues, might have done much to dissuade

the pirates from ever returning to the area.

For the next three days the pirate captains debated about what to do. They decided on April 5 to sail directly to the inlet opposite the unfinished Castillo. While debating about whether to enter the inlet and invade the town, they remembered what Ruiz had told them about the strengthening of the Castillo. Instead of risking their lives in such a dubious enterprise as attacking the town, they decided to head north to seek provisions along the coast.

Not content to allow the pirates free rein north of the town, the Spanish governor sent 30 soldiers in small boats to see what the pirates were doing and harass them as much as possible. The Spanish soon discovered that the pirates had sacked some villages in the St. Johns River and on Amelia Island. The pirates then went to present-day Cumberland Island off Georgia, where they careened their ships, buried their dead, and finally left the area. Meanwhile, they released several of their Spanish prisoners, but not Ruiz, the soldier who had done much to dissuade the pirates from attacking St. Augustine. For some reason, the pirates kept him with them and did not release him for another two-and-a-half years.

Until the residents of St. Augustine learned that the pirates had left the area, they were quite apprehensive about a return engagement. Several families and the missionaries returned to their houses in the town, but most of the townspeople and the soldiers remained at the Castillo for greater safety. Even if they stayed in their homes in the daytime, the townspeople usually went to the Castillo at night for protection. To accommodate the people who would return to the Castillo late in the evening to spend the night, the soldiers kept the gates of the fort open until 11 or 12 at night and relied on their recognition of the townspeople to let them enter, practices that officials later soundly criticized.

The soldiers and townspeople were on alert for a month, during which time they were not able to tend to such mundane but essential tasks as farming. If the pirates had known how undefended the town was, that everyone had retreated to the Castillo, they might have sacked the houses before sailing off. The governor had been able to rally the townspeople, most of whom crowded into the Castillo, to work day and night to strengthen the fort and put up temporary defensive posts, but the people's houses had been unprotected from attack. Fortunately, the pirates had sailed on to other, more promising places.

When reports of the 1683 pirate attack reached Spain in December of that year, the Board of War of the Indies (Junta de Guerra de las Indias) tried to exert diplomatic pressure on England to capture the responsible pirates and also considered putting a spy in Jamaica to report on pirate activities there. To punish the Spanish sentries who had been asleep when the pirates attacked the Matanzas watchtower, officials dismissed five men from the service and exiled them with rations to a Spanish province in Florida far from St. Augustine.

FURTHER READING:

Luis Rafael Arana and Albert Manucy, *The Building of Castillo de San Marcos*. St. Augustine: Eastern National Park & Monument Association for Castillo de San Marcos National Monument, 1977.

Albert C. Manucy, editor, *The History of Castillo de San Marcos & Fort Matanzas*. Washington: United States Department of the Interior, 1943.

"Pirates March on St. Augustine, 1683," *El Escribano* (April 1972), pp. 51-72.

CHAPTER 6

ANDREW RANSON, 1684

As the pirate stood on the gallows in St. Augustine in the fall of 1684, he knew his days were over. A silent executioner, in the midst of 12 soldiers, stood at the foot of the gallows, ready to do his dreaded deed at the command of the officer in charge. City inhabitants, friars from a nearby convent, and soldiers from the presidio stood by as the executioner placed the noose around the pirate's neck. With strong hands, the executioner began to twist the rope to choke the prisoner to death, a method called garroting. At six turns the pirate gasped in pain and collapsed. That might have been the end of another Florida pirate, but it was not to be.

The friars began to chant, the church bells started to toll, and many in the audience prayed for the dead man's soul. The executioner decided to give the rope one more twist—just for good measure. At that point the rope broke in two, and the limp body of the pirate fell to the ground. When the friars rushed up to examine the body, they discovered that the man was still alive.

Was it a miracle or just a defective rope? The friars guessed the former. The head friar threatened the astonished soldiers with divine wrath if they interfered and quickly had his friars move the body to the safety and immunity of the convent. As the pirate regained consciousness, they gave him a rosary to clutch and some time to ponder how close he had come to death. Bystanders claimed that tears streamed down the man's face, but whether they were of repentance for his past, relief from the agony he had gone through, or happiness at having beaten death we cannot be sure.

The pirate was Andrew Ranson, a man who had led a group of pirates to attack St. Augustine, was captured and sentenced to death, but was somehow spared from a gallows death. Born in England around 1650, Ranson had come to the West Indies in his twenties and had sailed to the Spanish Main, where he was captured and imprisoned in Cuba, probably for smuggling. How he had become a pirate is not clear. He might have mutinied with others under a stern taskmaster, or he might have been captured by pirates and forced to join them to save his life, or he might have first become a privateer preying on Spanish ships under the authority of a commission or letter of marque from the British; when his commission ended, he might have been reluctant to return to a poor-paying job on land or the miserable conditions in the British navy and instead opted to remain at sea as a pirate.

In 1684, Ranson joined Captain Thomas Jingle as the latter commanded six ships raiding Spanish possessions in Florida. One of the ships in the small fleet had participated in the 1683 pirate raid on St. Augustine mentioned in the last chapter; no doubt the crew on that ship told Jingle and Ranson of the vulnerability of the small Spanish outpost. Off the Florida Keys, they captured the Spanish frigate *Plantanera*, which was sailing from St. Augustine to Vera Cruz to collect the annual subsidy the Spanish

government paid its officials and soldiers in Florida. That money was essential for the Spanish to continue the Florida colony, since the lack of good farm land and natural resources provided little or no support to the outpost.

The pirates sailed along the west coast of Florida, ending up in the northern Gulf of Mexico, where five more pirate ships joined them. When they thought they had enough power to attack the Spanish settlement at St. Augustine, they headed for Florida's east coast. The small settlement at St. Augustine, with its 1,000 inhabitants, had stores and churches to rob, but not a big enough defense force to dissuade would-be attackers like Ranson. When he and his cohorts approached the town, a sudden storm blew five of the ships away, but the others decided on heading north to look for much-needed supplies. Ranson had his large ships remain offshore in deep water, while he and a group of pirates headed ashore in a smaller boat to obtain food and water and to think about how best to attack St. Augustine.

While there, Ranson and his men captured a messenger who had been sent to the governor in St. Augustine by Spanish sentries at the mouth of the St. Johns River who had seen the pirate ships sailing along the shore. Ranson interrogated the hapless prisoner about finding food and also about the defenses of St. Augustine. Meanwhile, some cattle ranchers, who had seen the English pirates land, found the pirate boat hidden near the shore and destroyed it with their hatchets.

At that point some 50 Spanish soldiers out of St. Augustine surprised the pirates on shore and captured them. Hoping to lure the pirates who had remained in the large ships off the coast, the Spanish soldiers took their prisoners to the mouth of the St. Johns and set an ambush. They forced Ranson to stand alone on the shore and call to his companions to come ashore (see picture). The pirates left the security of their ships and headed for shore in a small boat to see what Ranson wanted. Just as they were about to land, they suspected something was wrong, that it might be an ambush. They quickly turned around before the Spanish could rush out and seize them. The pirates returned to their ships, hoisted anchor, and sailed away.

The Spanish took their prisoners back to St. Augustine, where they interrogated them with the help of a few tortures. The pirates, out to strike as good a bargain as possible with their captors, told the Spanish about their plans to attack St. Augustine, where other pirates were, and who their leader was: Ranson. The interrogation by the Spanish authorities was reminiscent of a common pirate practice: mock trials. To pass the time of day and relieve boredom on their ships, pirates sometimes conducted mock trials in which crew members took turns being judge and prisoner. Such a practice enabled the men to vent their anger at fellow brigands for real or alleged crimes and slights, but it also gave them practice in case they ever stood before a real judge, as was the case in St. Augustine.

In this interrogation, several pirates testified against Ranson; for example, one Spanish sailor told how Ranson had beat him mercilessly, even threatening to cut off his head, in order to extract information about Spanish towns and treasure in south Florida. Spanish sailors on the *Plantanera*, which Ranson and his men had captured in the Keys, also testified against him.

The Spanish governor had Ranson's cohorts sentenced to long-term hard labor, a severe sentence that was later reduced to ten years, while their ringleader, Ranson, was to be publicly garroted near the gallows. Execution by garrot ("gar-ROTE," also spelled "garotte" and "garrotte") consisted of strangulation, sometimes with an iron collar that was tightened by a screw. The condemned Ranson protested that he was innocent and appealed to the head monk, an appeal that saved his life after the incident of the broken rope. The prisoner could be expected to make the appeals that many pirates in his position had made: that he was merely carrying out orders from a more senior pirate or that he was on shore above St. Augustine merely to look for food. In any case, his arguments to the monks who attended his last days, that he was a Catholic who deserved mercy, convinced them to help him.

Whether a silver oar, the symbol from early days of a pirate execution, led the procession of the condemned prisoner to the gallows is not recorded, and, in fact, the poor outpost of St. Augustine probably did not have such an expensive symbol. Nor do we know if the prisoner, as was the custom at many pirate executions, made a speech. Dressed in the best suit of clothes he had or could borrow, the pi-

rate would either curse the onlookers or, as was usually the case, would repent of his evil ways and blame his waywardness on drink or greed. He knew that the authorities might take down his dead body after the execution and hang it for all to see, especially those sailors at sea who would pass that way and who might have had some inclination to piracy.

After the monks had whisked the limp body of Ranson to the safety of the convent, government officials demanded that they turn the body over to them so that they could finish carrying out the death sentence. The monks refused, and the tug-of-war between church and civil authorities that would last several years began. The monks, who threatened the governor with excommunication if he violated the immunity of their convent to arrest the pirate, claimed that Ranson should have ecclesiastical immunity. The governor claimed he should have another rope, a much stronger one, put around his neck.

The governor, helpless before the monks, could at least discipline the soldiers who had allowed the rope to break. He discharged some of them and posted others to remote and difficult posts. The governor himself left Florida for good in 1687, having failed to dislodge the lucky pirate from the convent. When the new governor arrived and made it known that he was looking for more manpower to finish the Castillo de San Marcos, the ever-resourceful Ranson pointed out that he had been trained as an engineer and carpenter and would be glad to help out, if the Spanish authorities spared his life. The governor agreed, and Ranson moved into the Castillo to help in its construction.

Meanwhile, Spanish authorities summoned the chief monk to Madrid in 1692 to explain why they should not execute Ranson. To prove his point that the pirate's escape from certain death was a miracle, the monk presented the severed rope itself, but to no avail. Two friars were exiled from Florida for defending Ranson. Still the pirate continued alive

and well in St. Augustine. It seems the Spanish authorities there were too busy battling England to worry about the pirate in their custody. Governor Moore of South Carolina was much more of a problem as he led a band of troops south, captured St. Augustine, and laid siege to the Castillo, withdrawing only when he could not destroy it.

During the two-month-long siege of the Castillo by Governor Moore's troops, the Spanish governor, who could not spare any troops to guard Ranson and the other prisoners, offered freedom to any prisoner who would help the Spanish defend the fort from the English invaders. The ever-resilient Ranson offered his services, and the Spanish began using him as an interpreter to interrogate captured English soldiers. When the siege was lifted, the governor kept his word by recommending that Ranson and other prisoners who had cooperated be set free.

Although we have no records of what happened, Ranson probably regained his freedom and either returned to his wife in the West Indies or remained in Florida. The last English pirate to harass St. Augustine, a man who had lived under a death sentence for many years, walked out of St. Augustine a free man. Whether it was a miracle of divine intervention or just a faulty rope cannot be proven at this late date. Ranson had come as close to death as one could and still live to see another day.

Unlike most pirates, Ranson may have ended his days peacefully rather than on the gallows. If so, he was the exception to the rule, as many pirates died in battle, prison, or exile or at the hands of an official executioner. Very few died in their beds. Ranson must have had some great stories to tell in his old age, stories of how he had beaten the gallows at the last possible moment.

FURTHER READING:

J. Leitch Wright, Jr., "Andrew Ranson: Seventeenth Century Pirate?" *Florida Historical Quarterly* (October 1960), pp. 135-44.

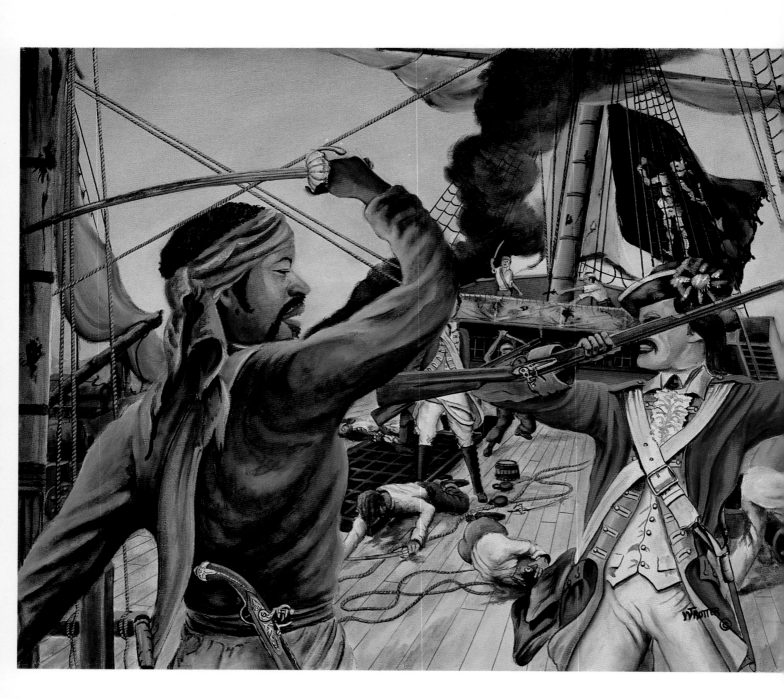

CHAPTER 7

\mathscr{B}LACK CAESAR, 1700

The islands below Key Biscayne seem idyllic to most visitors today. Busy U.S. 1 hurries drivers from Homestead to Key Largo and eventually Key West, but north of Key Largo lie a number of islands that hold a story only hinted at by the name of a channel there (Caesar's Creek) and a large rock (Caesar's Rock). Those names commemorate the area's most infamous pirate: Black Caesar.

In the 1700s and 1800s, the topography of the Upper Keys favored the pirates who used the area as a staging place. The Florida Reef offshore made sailing those waters particularly treacherous for seamen unfamiliar with the place. Summer hurricanes forced many a ship onto the deadly reef with the result that those living on the islands, whether Indians, wreckers, or pirates, were able to salvage treasures and valuable cargoes. The many inlets and shifting islands also provided hundreds of hiding places for pirates lurking along the coast, ready to dash out and attack passing ships.

And there were many such ships. The Spanish treasure fleets, having loaded up in Cuba with silver and gold from Central and South America, would make the long trip back to Spain along the Florida coast. Even if they escaped hurricanes and reefs and privateers, they still had to run the gauntlet of the many pirates who waited for them along the way. Black Caesar was one of those pirates.

The legend about this fierce man goes back to the early slave-trading days in the Caribbean. According to various accounts, Black Caesar was an African chief known far and wide for his huge size, immense strength, and keen intelligence. European slave traders in Africa tried many ways to lure him onto their ships with the hope of capturing him, taking him to the New World, and selling him for a handsome price. But they could not trick him onto their slave ships since he knew what they wanted and always thwarted them...until the day he discovered the fascination of a watch.

One cunning slave trader brought out a watch, let Black Caesar listen to it ticking, taught him how to wind it to keep it going, lit a fire by shining the watch's crystal face onto some flammable material, and allowed him to hold it in his hands. The huge man was fascinated by such power and let his defenses down a little. Maybe the sea captain was honest when he promised to show Black Caesar more wonders on board his ship. "I've got more objects on the ship to show you," the slaver promised, "but they're too heavy and too numerous to bring on shore. Come with me and I'll show you all of them."

Caesar and his warriors went on board the ship and marvelled at all the food, musical instruments, and jewels the captain brought out. The silk scarves felt so smooth to the Africans as they wore them on their shoulders; the food tasted marvelous; the jewels looked bright on their bodies. All the while, the captain had his crew very quietly weigh anchor and set sail. Little by little the ship inched its way out from the safety of shore to the open sea.

Finally, the captain removed the jewels and furs

from the cabin and revealed his true purpose to the Africans. They angrily charged at the sailors, but the guns and swords used by the Europeans quickly overcame the brute strength of the Africans. It took a long time for the crew to subdue Black Caesar and the warriors, but they finally succeeded. The captain aimed his ship for the New World, confident he would reap a rich reward for his captives.

One man among the crew, a white man who was not afraid of Black Caesar, befriended the huge man and became the only one that Black Caesar would take food and water from. During the long voyage across the Atlantic, the two men began communicating with each other and became friends. The initial sign language they used between them slowly evolved into better and better communication. The mate came to like the slave and spent more and more time with him.

The slave captain had planned carefully how to restrain the African slaves, how to keep them alive on the long transatlantic trip, and how to sell them to the highest bidder, but he had not planned on a hurricane to wreck his ship. As they approached Florida, a huge storm buffeted the ship and threatened to tear it to pieces. When it became clear that the ship would wreck on the Florida Reef, the mate went below decks and freed Black Caesar. The two men then went on the deck, forced the captain and crew into a corner, and boarded a longboat with supplies and ammunition. The two of them then cast off in the boat and headed to shore, unmindful of the doomed ship behind them.

The wind and waves pushed the little boat to shore, where they waited until the storm passed. No one else seems to have escaped the sinking slave ship. The two men let their wet supplies dry out, and then they began to plot their future. They decided to use their longboat in a daring scheme to trick passing ships.

When they spied a ship off the reef, they would put out in their boat and pretend they were shipwrecked sailors. The captain of the passing ship would invariably take them on board and offer them assistance. At that point Caesar and the mate would bring out their guns and force the crew to load the longboat with supplies and more ammunition. If the captain and crew resisted, the two men would sink the ship with all aboard (see picture). The two pirates lived well this way and began hoarding a large supply of goods and jewels, much of which they buried on Elliott Key.

All might have gone well for many years except that the mate took back to the island a beautiful girl they found on one of the ships they looted. The two men soon argued over the woman, brought out their weapons, and fought a duel. Black Caesar killed his friend, took the woman for his own, and continued his piracy as a one-man band.

As time went on, Caesar took more pirates into his confidence and used larger boats to attack the passing ships. When his crew had to hide from danger, they would escape into the inlets and onto the mangrove islands. There they would use a metal ring embedded in a rock, run a strong rope through the ring, heel the boat over, and hide it in the water until the patrol boat went away. Or they would lower the mast and sink the ship in shallow water; later they would cut the rope or pump out the water, raise the boat, and continue with their raids. To this day the rock, which is between Old Rhodes Key and Elliott Key, is called Caesar's Rock.

One of the stories about Black Caesar told of the harem he collected on his island. At one point he supposedly had more than 100 women he had seized from passing ships. He might also have had a prison camp on Elliott Key, where he kept his prisoners in stone huts, perhaps hoping to ransom them for even more wealth. When he left the island to pursue ships elsewhere, he did not free his prisoners, most of whom starved to death.

A few small children apparently escaped, but stayed on there, subsisting on berries and shellfish. They developed their own language and customs and gave rise to the Indian superstition that the place was haunted. A 1922 novel, *Black Caesar's Clan*, is about the people who live near Caesar's Creek, people who don't like to be called conchs and who can scare off intruders looking for buried treasure. Stories persist to this day that Caesar and his men buried some 26 tons of silver bars on the island, but none seems to have surfaced yet.

The cruelty that Caesar showed to his prisoners was typical of pirates everywhere. Despite the glamorous picture readers have from James Barrie's *Peter Pan* and Robert Louis Stevenson's *Treasure Island* or that movie-goers have from such productions as

The Pirates of Penzance, the pirates were mean people. Stories abound of cruel punishments inflicted by pirates, such as forcing a prisoner to drink vast quantities of rum and then watching him drown in the sea or sewing up a prisoner's lips with twine to stop him from complaining. When word of such cruelties spread on the high seas, merchants of captured vessels tended to offer no resistance to pirates.

What piracy offered Caesar and the other men who entered its ranks was personal liberty and the chance to have an equality with everyone on board, including the captain, something ordinary sailors would not have in navies. In the case of Black Caesar, that personal liberty was even more important since he had escaped the slave ship.

Black Caesar left Biscayne Bay in the early 1700s to join forces with the more infamous Blackbeard, Captain Edward Teach. He may have joined with Blackbeard because of fewer opportunities to plunder ships off Key Biscayne or because of the chance to serve with one of the most notorious pirates in history. In the 40-gun *Queen Anne's Revenge*, they plundered ships up and down the eastern seaboard.

In September 1718, Black Caesar was with Blackbeard on Ocracoke Island off the tip of Cape Hatteras when naval forces attacked the pirates and defeated them. At that point Black Caesar realized that his piracy days were about to end and he would have to face an execution squad or be made a slave. Instead, he chose to end his life and the lives of others on the ship.

As instructed by Blackbeard, Black Caesar put down a trail of gunpowder leading to the magazine that stored explosives. All he had to do was light the gunpowder and the whole ship would blow up, killing not only the pirates but the British forces as well. He started to do just that when a prisoner being held below decks leaped on Black Caesar and prevented him from igniting the gunpowder. He wrestled Black Caesar long enough for the navy men to take the pirate into custody. The British took him to Virginia for trial and hanged him in Williamsburg.

The execution might have been the end of Black Caesar, but not so. One hundred years later, another pirate of mixed parentage arrived in Biscayne Bay, adopted Black Caesar's name, and began attacking passing ships. By 1828, the United States owned Florida, having acquired it from the Spanish seven years earlier. President Andrew Jackson wanted to rid the area of pirates. Black Caesar II escaped to the west coast of Florida, where he was finally captured and, according to one story, taken to Key West, tied to a tree, and burned to death. Some say that the widow of a preacher whose eyes Black Caesar had burned out lit the fire that ended the life of the notorious pirate.

Coins, skeletons in coffins, and old muskets that occasionally surface on Virginia Key and Elliott Key conjure up old stories of buried treasure and pirate lore. If tractors and backhoes clearing the land on the mainland or the islands uncover more loot, you can be sure that tales of the Black Caesars will surface again.

FURTHER READING:

Love Dean, "Pirates and Legends." *Florida Keys Magazine* (1st quarter, 1981), pp. 10-14.

Albert Payson Terhune, *Black Caesar's Clan.* New York: George H. Doran Company, 1922.

David O. True, "Pirates and Treasure Trove of South Florida." *Tequesta: The Journal of the Historical Association of Southern Florida* (1947), pp. 3-13.

Jim Woodman, *The Book of Key Biscayne.* Miami: Miami Post, 1961.

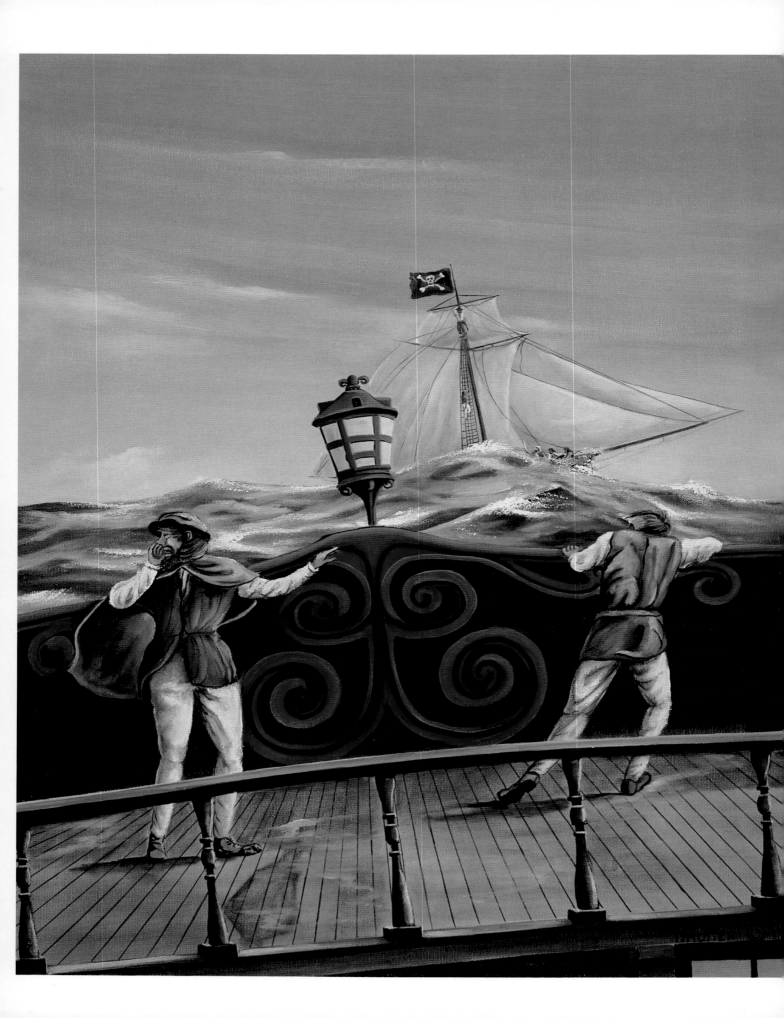

CHAPTER 8

\mathcal{H}ENRY JENNINGS, 1715

Pirates were a very adaptable group of men and women. If they could find a treasure they could take without much risk to themselves, they would do it. And if they could escape piracy with a royal proclamation, especially if they had secured sufficient funds for a pleasurable retirement, they might very well do that. Such was the case with Henry Jennings, an English pirate and native of Jamaica who preyed on the Spanish in and near Florida and who began what some call "the Golden Age of Piracy" in the West Indies. When he was offered a royal pardon, he took it, gave up piracy, and retired to a life of luxury.

Pirates were usually very clever and cautious people. While most pirates would not attack the Spanish Treasure Fleet (also called the Plate Fleet) directly as it sailed from Cuba and Mexico up the Florida coast and back to Europe, they did stalk the ships in hopes of attacking a straggler, a ship that could not keep up with the rest of the fleet (see picture). Pirates were also on the look-out for sunken treasure ships, especially if others had begun salvaging them.

In July 1715, the Spanish Treasure Fleet set out from Cuba with a vast horde of treasure from South America and Mexico. Forty miles south of Cape Canaveral off present-day Fort Pierce, a huge hurricane wrecked ten of the 11 ships, scattering debris and treasure over a large area. Despite the loss of the ships, 1,500 survivors made it safely to shore and eventually back to Havana, where they reported what had happened. The Spanish soon began making plans to send salvage teams to the area to recover as much of the sunken treasure as possible.

The Spanish viceroy at Havana sent a diving and salvaging crew, along with 60 soldiers to protect them, to the site of the wreck on the Florida coast. There Indian divers, armed only with strong lungs and a heavy stone to help their descent, dove again and again and recovered a large amount of the ships' treasure. When the divers brought up merchandise and treasure, they deposited it all at a base camp on shore.

Meanwhile Henry Jennings, an Englishman in Jamaica, began making his own plans concerning the Spanish wreck. At that time he was in charge of an English ship, the *Bathsheba*, which Governor Archibald Hamilton of Jamaica had commissioned to hunt pirates. Jennings had been a privateer and supposedly knew enough about the habits of pirates to be able to search them out and capture or kill them. However, as with so many pirates, Jennings had learned how rich a successful privateer/pirate can become and how exciting such a life can be in comparison to the hard life of a seaman.

So around that time he decided to give up the respectable life of a British sea captain and resume the exciting, more lucrative, maybe glamorous life of a pirate. He may have been influenced by what he heard was going on in the salvaging of the Spanish Treasure Fleet on the east coast of Florida. Word of the Spanish salvaging had spread throughout the

West Indies, a place teeming with unemployed sailors and pirates looking for prey. The fact that Spain and England were not at war did not bother the pirates. Henry Jennings was one of those who saw in the treasure camp a rare opportunity and one to be seized quickly.

Some people thought the English governor of Jamaica was aware of Jennings' plans to become a pirate and might have encouraged him, especially if Jennings would limit his plundering to Spanish ships and maybe secretly provide the governor with some of the loot they would bring back. In any case, Jennings set off with his fleet of two ships, three sloops, and some 300 men for the east coast of Florida south of Cape Canaveral. Like sharks attracted to the scent of blood, these men were lured by the prospect of easy pickings, and they were right.

In November 1715, they located the Spanish treasure camp, scattered the outnumbered Spanish soldiers, and confiscated as much treasure as they could carry: some 300,000 pieces of eight. Such a profitable undertaking, with relatively little trouble, was more appealing to the pirates than attacking a heavily armed Spanish galleon, and they made plans to return there in the not-too-distant future to relieve the Spanish of even more recovered treasure.

As they sailed back to Jamaica, the pirates came upon a heavily laden Spanish merchant ship, which they promptly captured and plundered. Instead of killing the crew and sinking their ship, Jennings released the crew in their ship, confident that they would sail away, happy that they were still alive. Unexpectedly and daringly, the Spanish captain actually followed the pirates into Jamaica, where he noted how happy the merchants were at the prospect of having so many plundered goods to sell. Then the Spanish captain turned back and sailed to Cuba, where he reported the incident to the Spanish viceroy.

That official, having already heard of Jennings' pillaging of the Spanish treasure camp, was outraged. He contacted the English governor of Jamaica and insisted that officials there hang the pirates. If they refused, the Spanish viceroy would hang any Englishmen he could find, including a number of English merchants in Havana. The English governor of Jamaica answered that he knew nothing of the pirates and that there must have been a mistake in the information. If the viceroy hanged any innocent Englishmen in Cuba, the English governor would flog any Spanish he could find in Jamaica.

Meanwhile, Jennings and his pirates were the toast of the town in Jamaica, not only for their daring attack but also for the many looted supplies they brought for sale to anyone with money. The rum must have flowed freely in the dockside taverns. The royal governor, in no mood for a tit-for-tat blood feud with the Spanish, complained to the local merchants, who advised Jennings to quietly leave Jamaica and go elsewhere. The ever-prudent Jennings sold the rest of the plundered booty and left with his pirates.

Just when the Jamaicans and the governor were gloating over how they had solved that sticky problem, they learned that Jennings had struck again. When the pirates had left Jamaica, they had overtaken a Jamaican merchant vessel, plundered the ship of anything usable, and stripped the captain and crew of all their clothes. The merchant ship had sailed back to Jamaica with a mortified, angry captain and crew. The governor and officials there had had enough, reasoning that attacking the Spanish was one thing, but attacking the English themselves was a different matter, was in fact piracy and something they did not appreciate.

Piracy was reaching a fever pitch in the West Indies with pirates roaming through the area, attacking any ship they found. To Jennings and his band it did not matter if the prey was English or Spanish, but authorities on both sides were out to capture him any way they could.

A Spanish squadron of ships sent out to capture Jennings came upon a group of Englishmen cutting logwood on one of the Spanish islands. When the Spanish landed, the English scattered to the woods and the Spanish burned the English boats. Jennings came to the area a few days later, discovered the plight of the English woodcutters, and offered them the chance to join him — or remain stranded on the island. The woodcutters took a few minutes to think about the options and quickly joined the pirates.

When the pirates captured another ship, they added it to their little fleet and manned it with the woodcutters and some of their own crew. In this way they soon had a fleet that was too big to operate as one, so they split into two groups. Jennings' fame

began to spread throughout the area, and more and more sailors and merchantmen joined his forces or became pirates under other leaders.

The pirates operating throughout the West Indies found many inlets and isolated islands that would shelter and hide pirate ships for a rest or for darting out after passing ships. The men could find wood and water on the islands, sandy beaches for camping out, plentiful food, suitable places for cleaning their ships of barnacles and weeds, and tricky channels that would cause much trouble for the larger ships so popular with merchants.

In January 1716, just two months after his first successful raid on the Spanish treasure camp on Florida's east coast, Jennings attacked again. He had his men sail their ship, the *Bathsheba*, to a place near the coast and waited until darkness set in to land. Early the next morning, the pirates attacked the camp and plundered the warehouse full of salvaged treasure. The head of the Spanish salvaging efforts offered Jennings 25,000 pieces of eight if the pirates would abandon their raid and sail off. Jennings took the 25,000 pieces of eight, but continued pillaging, which the outmanned Spanish could not stop. The pirates even stripped the Spanish salvagers of their valuable possessions, took away some of the Spanish cannon, and sailed away.

When the Spanish eventually left the site in April 1716, after having recovered some 80% of the sunken treasure, Jennings returned to the Florida coast, the place where he had made two successful raids on the Spanish treasure camp. This time, though, he led efforts to recover even more of the sunken treasure lying on the seabed. Such work was certainly more difficult and time-consuming than his quick raids on the Spanish treasure camps, but he was not one to miss any lucrative opportunity to recover treasure.

The following year saw the end of Jennings the pirate. When Captain Woodes Rogers took over as governor of the Bahama Islands, he issued a royal proclamation dated September 5, 1717, that pardoned all pirates who would surrender within the coming year. Jennings, who had done very well as a pirate in accumulating wealth and prestige, determined that he would be far wiser to give up piracy than risk capture and death by more plundering. He surrendered to authorities and retired to Bermuda, where he lived the rest of his life as a wealthy, respected member of society.

Henry Jennings was one of the best examples of a pirate who prospered from his piracy and retired to a life of luxury rather than ending his days hanging from a yardarm. He was definitely the exception to the rule, as most pirates met their death at an early age and in battle, prison, or exile. Even among the 400 pirates who took advantage of the royal pardon offered by Governor Woodes Rogers, half of them soon grew tired of their peaceful, dull lives and returned to piracy and the dangerous, exciting life on the high seas.

FURTHER READING:

Robert F. Burgess & Carl J. Clausen, *Gold, Galleons and Archaeology*. Indianapolis: Bobbs-Merrill, 1976: Chapter 7: "Of Pirates and Salvagers."

M. Foster Farley, "Woodes Rogers: Privateer and Pirate Hunter." *History Today* (August 1979), pp. 522-31.

Kevin M. McCarthy, *Thirty Florida Shipwrecks*. Sarasota: Pineapple Press, 1992: Chapter 7: "*Urca de Lima*, 1715," pp. 32-35.

Frank Sherry, *Raiders and Rebels: The Golden Age of Piracy*. New York: Hearst Marine Books, 1986.

George Woodbury, *The Great Days of Piracy in the West Indies*. New York: Norton, 1951.

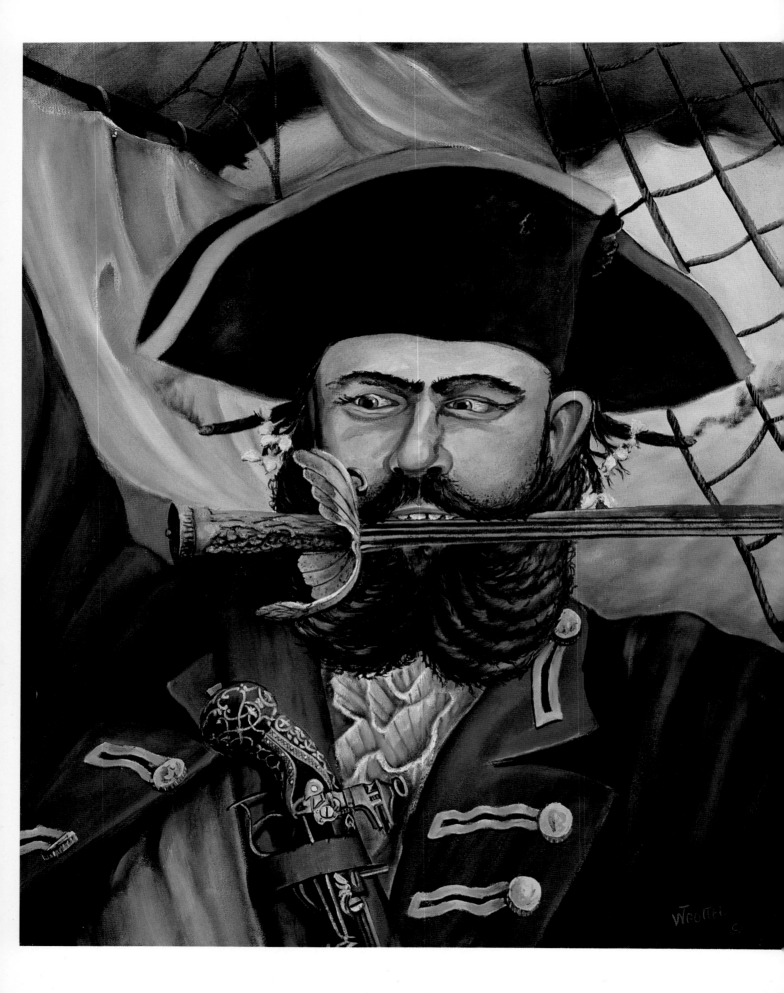

CHAPTER 9

\mathscr{B}LACKBEARD, 1718

One of the ferryboats that takes cars and people across the St. Johns River at Mayport is called *Blackbeard*, a name which recalls one of history's most infamous pirates and one with connections to Florida. In the early 18th century, Blackbeard used to roam the eastern shore of the United States, preying on ships, attacking towns, and wreaking havoc. His Florida connections are somewhat vague, but, as we saw in Chapter 7, we do know that he lured Black Caesar away from the Miami area to join his band, and he sailed offshore on his way between the Carolinas and the Caribbean. If we cannot say for certain that he captured ships off the Florida coast, his presence certainly had an unnerving effect on Spanish ships using Florida ports, especially St. Augustine.

Blackbeard was born Edward Teach (or Thach) in Bristol, England, in the late 17th century. He served in Queen Anne's War as a privateer out of Jamaica in the early 1700s and became well-known for his boldness and bravery in battle. Around 1716, finding that the end of hostilities in the Caribbean put an end to his naval career, he joined other pirates out of New Providence in the Bahamas and began attacking ships in the Florida Channel. When in 1717 he seized a large French merchantman that he particularly liked, he changed the name of the captured ship to the *Queen Anne's Revenge*, mounted 40 guns, and went looking for prey with a band of like-minded pirates.

Teach received his famous nickname from the thick black beard that covered much of his face. He liked to twist that beard into little tails, stick ribbons in those tails, and turn up those tails towards his ears, making a fearsome sight. When he was about to go into battle, he stuck slow-burning pieces of matter into his beard and lit them; the little fires burning on each side of his face gave him even more of a devil-like appearance. He would put a pistol in one hand and his cutlass between his teeth and lead his troops onto an enemy ship, yelling and screaming at the terrified passengers. Standing 6'4" tall and weighing more than 250 pounds, he was a gigantic man who loved to inspire fear in everyone (see picture and cover).

Although Blackbeard was known for his cruelty, he could at times be quite civilized. For example, instead of killing his prisoners, he would make sure the crews of captured ships got to shore safely before heading off with the booty and sometimes the ship. And he did not hesitate to battle the British if he thought he could beat them. Once when the 30-gun British man-of-war, HMS *Scarborough*, came upon him, Blackbeard fought the British for three hours before forcing them to retreat to Barbados.

He was also well-known for his long drinking bouts and insane sense of humor. Once, after a drinking session with two crewmen below decks, he blew out the candles and began shooting at the crewmen with his pistols. He wounded one of the men, Israel Hands, and lamed him for life. When confronted by the other pirates and asked for an explanation,

he said that he had to occasionally kill one of his men in order for them to obey and fear him.

When Captain Woodes Rogers became governor of the Bahamas and issued a proclamation in 1717 pardoning those pirates who would agree to live a peaceful life, Blackbeard refused and, instead, headed off for the Carolina-Florida coast. After capturing more prizes, he led his fleet of six ships and crew of around 400 men along the Florida coast in the spring of 1718. They captured several more ships, including a brigantine and two sloops. Then they had to decide what to do next. Blackbeard might have thought of following Sir Francis Drake's example and sacking St. Augustine, a Spanish settlement with only about 300 defenders, but the town did not offer the riches of more northern sites, and the Spanish, who faced hostility from their English neighbors to the north, might have put up fierce resistance, something Blackbeard did not need.

So in 1718 he sailed north before arriving at Charleston, South Carolina, a much more alluring target and one that was weakened from having fought two Indian wars. First had been the war with the Tuscarora Indians, 1711-1715, and then the war with the Yamassee Indians, 1715-1718, both of which led to a huge debt, much loss of property, and the death of some 400 inhabitants. The townspeople were worried about a possible slave uprising, many soldiers were away guarding the frontier, and the harbor had only token defenses. Blackbeard knew he had made the right decision about which place to attack.

The Spanish in St. Augustine to the south were pleased at what was happening in Charleston. They feared that the English in South Carolina might attack their Florida settlement or at least Spanish ships sailing along the coast. They even thought the South Carolinians might be harboring the pirates who preyed on Spanish shipping. No doubt they looked on with glee at the worsening situation in Charleston.

Blackbeard had his men lie in wait outside the Charleston harbor for nearly a week, during which time they captured nine ships and several important local citizens. Incoming and outgoing ships learned of Blackbeard's blockade and stayed put, temporarily ending all the city's maritime trade. All of this further worsened the situation for the Charles-tonians. When Blackbeard captured a member of the South Carolina governor's council, he decided to try to ransom him for something his crew desperately needed: medicine to treat the syphilis that was spreading among the crew. He gave the city two days to comply with his demands or he would cut off the heads of his captives and deliver them to the city. He would then sink his captured ships and attack Charleston. City officials had little choice and complied with the pirate's demands, after which he released his prisoners and ships and then sailed north to the friendlier confines of North Carolina, some of whose officials were in cahoots with him.

Once there, Blackbeard dismissed most of his 300-man crew because his forces had become too large. Dividing the booty up among so many greatly diminished each man's share. Also, having a large fleet made it difficult to hide them from pursuit. He chose Black Caesar and about 40 others to join him on his ship, the sloop *Adventure*, as they cruised the coast off the Carolinas. He eventually made his way back to a safe port in North Carolina, where Governor Charles Eden gave him an official pardon and presided at the pirate's wedding to a 16-year-old, possibly his 14th wife. The youngster might not have known at that point about one of the pirate's favorite pastimes: shooting a pistol at the feet of his dancing wife to make her dance faster or higher. After this latest wedding, Blackbeard continued his crime spree, capturing more ships at sea and selling some 90 slaves to North Carolinians.

A group of honest North Carolinians, fed up with the collaboration of their governor with Blackbeard, appealed to the lieutenant governor of Virginia, Alexander Spotswood, who feared that a pirate stronghold in North Carolina would threaten Virginia shipping. The governor contracted with Lieutenant Robert Maynard of the English Royal Navy, and the latter proceeded south with two small sloops. Off Ocracoke Inlet the two forces met.

Blackbeard had heard that Maynard was looking for him and made a few preparations for the expected battle, but then spent several days in a drinking orgy. The drinking and dancing and whoring that went on for nearly a week must have weakened the pirates, and certainly affected their thinking. Blackbeard and his pirates finally spotted the telltale masts of the English navy, which was try-

ing to sneak up on them, but the pirates were cocky enough to believe that no one could catch them. Blackbeard's luck, however, was about to run out, just as the wind and tide were doing for his ship.

When asked by one of his men if anyone knew where his treasure was hidden, just in case he should die in the next day's battle, Blackbeard responded that nobody but himself and the devil knew where it was and that he who lives the longest might find it. The story that Blackbeard buried huge treasures has given rise to many treasure seekers in North Carolina, Florida, and elsewhere.

The next morning, when Blackbeard saw how close Maynard's troops had come, he readied his guns, grabbed his cutlass, lit the matches in his hair, and prepared for battle. When the ships neared one another, Blackbeard shouted out: "Damn you for villains. Who are you?"

"You may see by our colors," Maynard answered.

"Damnation seize my soul if I give you quarter or take any from you," Blackbeard responded.

Maynard concluded the shouting match by saying that he expected no quarter from Blackbeard and would give none.

Right before the ensuing battle, Maynard had hidden his men below decks to prevent more from being killed by a broadside and to deceive Blackbeard. The scheme worked. Seeing so few on deck, Blackbeard thought that his cannon had killed the others and, when the ships came together, he had 14 of his crew board the English ship. At that point Maynard's men came on deck and engaged in hand-to-hand combat.

Finally, Maynard and Blackbeard faced each other, intent on ending the battle as quickly as possible. Maynard wounded the pirate with numerous bullets, but still Blackbeard fought on. Finally, after some 25 wounds, the pirate tried to fire his pistol one more time, but collapsed and died. Black Caesar, down below, tried to blow up the ship, but was prevented from doing so. Some ten men on each side were killed in the battle, and others died later from wounds incurred during the fighting. Before taking his prisoners back to land, Maynard ordered his men to cut off Blackbeard's head, hang it from the top of the English ship, and toss the rest of his body overboard.

As with so much pirate lore, a story grew up around that action, a story that has the headless corpse swimming around and around the English ship looking for its head before finally sinking to the bottom of the sea. Maynard sailed back to Virginia with Blackbeard's head dangling from the end of his bowsprit, partly as a warning to any would-be pirates in his own crew and also as proof to the Carolinians and the Virginia lieutenant governor that Blackbeard was dead. Officials on land later tried the captured pirates in Williamsburg and hanged 13 of them.

To this day, there are stories in North Carolina's Outer Banks that a silver-plated cup exists that was made from Blackbeard's skull. The eye sockets on the lip of the cup make drinking from it an eerie experience. Blackbeard himself would have probably appreciated the cup made from his skull.

FURTHER READING:

Clinton V. Black, *Pirates of the West Indies*. Cambridge: Cambridge University Press, 1989, pp. 87-100.

Cyrus H. Karraker, *Piracy Was a Business*. Rindge, N.H.: Richard R. Smith, Publisher, 1953, pp. 140-164.

Robert E. Lee, *Blackbeard the Pirate: A Reappraisal of His Life and Times*. Winston-Salem, N.C.: John F. Blair, 1974.

Ben Stahl, *Blackbeard's Ghost*. Boston: Houghton Mifflin, 1965.

Judge Charles H. Whedbee, *Blackbeard's Cup and Stories of the Outer Banks*. Winston-Salem, N.C.: John F. Blair, 1988.

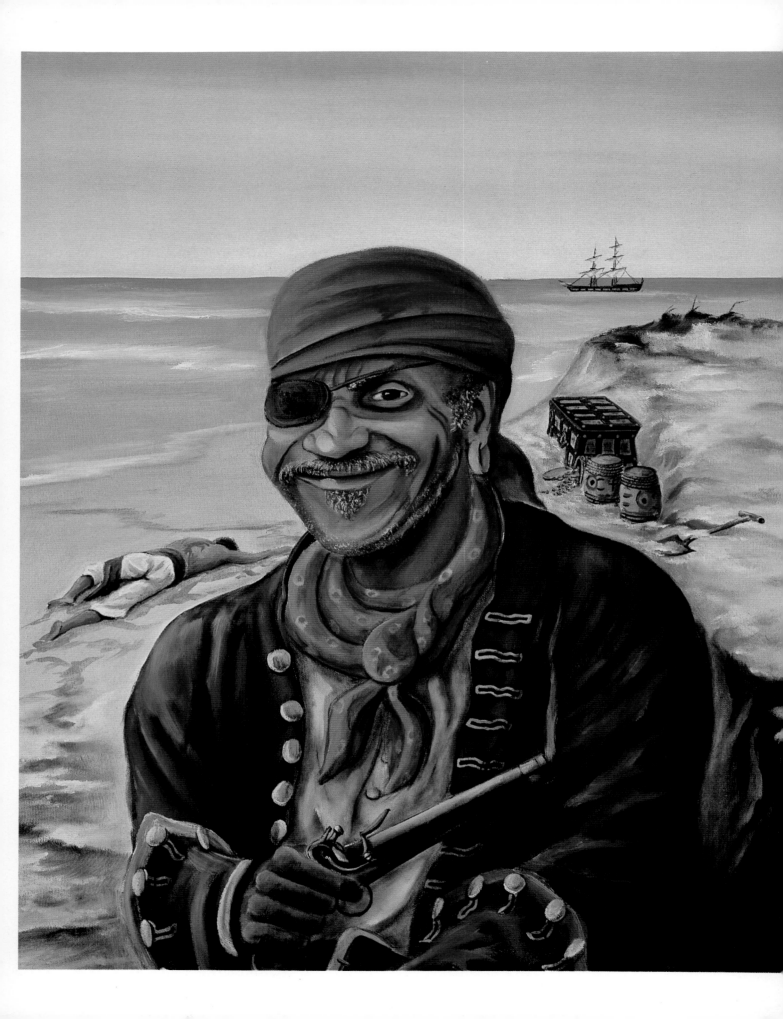

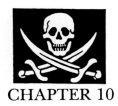

CHAPTER 10

\mathscr{F}RANCISCO MENÉNDEZ, 1741

When slaves from British plantations in the Carolinas and Georgia looked south to Spanish Florida in the 18th century, they saw something that seemed unattainable in their present surroundings: freedom. All they had to do was reach that promised land of Florida, a task that was difficult and almost impossible for all but the strongest and most determined. The British did their best to prevent the slaves from heading south, but still they came. When the British blocked the roads, the slaves came by boat. If they couldn't find a boat, they stole a horse. If they couldn't do that, they walked or ran or even swam to Florida.

In developing their colonies, the Spanish had tried to enslave the native Americans, the Indians, but found them less and less useful because they often returned to their own villages and refused to work for the Spanish. So the Spanish encouraged any runaway slave to head south because they needed laborers to till their fields, build their forts, and defend outlying towns. True, the runaway slaves had to convert to Catholicism in order for the Spanish to allow them to stay, but they were willing to do that. For the former slaves, converting to a new religion was a small price to pay for the freedom they desperately craved. The new converts were able to celebrate Catholic feast days in their own way, for example, dressed in traditional African costumes and playing African musical instruments.

The skills that the slaves brought with them, including the knowledge of several European and In-dian languages and artistic traditions from African tribes, added much to the Spanish town. They no doubt, in addition to their newly adopted Catholicism, also practiced some African religious customs that their former slave owners would have prohibited. Plus, the blacks would be expected to farm the land, something that Spanish soldiers and merchants were reluctant to do.

Beginning around 1687, runaway slaves from the Carolinas and Georgia headed for freedom, not north as slaves would do 150 years later, but south, across north Florida to St. Augustine. There, in addition to using the blacks in building the new stone fort, the Castillo de San Marcos, and making St. Augustine the first successful Spanish town in Florida, the Spanish authorities set up the slaves in their own settlement, a place they called Gracia Real de Santa Teresa de Mose, what we call today Fort Mose (pronounced "Moh-say").

Instead of placing the town south of St. Augustine and away from any invading British army, the Spanish placed it about two miles north of St. Augustine, where it would serve as a buffer for the Spanish inhabitants. About 100 runaway slaves lived there at any given time from about 1738 until 1763, at which time they joined the Spanish, who were ceding Florida to the British and leaving the territory for Cuba.

In 1738, the Spanish governor appointed one of the ex-slaves, Francisco Menéndez, to command a group of former slaves against a British invasion.

51

Menéndez was a Mandingo from West Africa, a man who had escaped from British slavery and for three years fought with the Yamassee Indians against the British in the Carolinas. He then joined many other runaway slaves and headed south to St. Augustine to try to find freedom and the chance to raise a family in hospitable surroundings.

After they successfully defended St. Augustine, Menéndez and the other blacks found that the Spanish still considered them slaves and that it would take four years of loyal service before the Spanish crown would grant them freedom. That was not acceptable to them, so they began to use the Spanish legal system to right their wrongs, something that would have been unthinkable for the former slaves on the Carolina plantations.

Menéndez sent petition after petition to the Spanish authorities, pointing out how the blacks had faithfully fought for the Spanish and loyally served the crown. Some of his former allies, the Yamassee Indians, supported Menéndez's petition; they pointed out how loyally and how well he had fought against the British for three years. Finally, in 1738, the Spanish governor acquiesced and granted the blacks the freedom they had so desperately sought. Two years later, the British, led by Governor James Oglethorpe of Georgia, invaded north Florida and attacked Spanish sites. The blacks fought bravely and determinedly with the Spanish and eventually forced Oglethorpe to retreat.

The relationship between the Spanish and the British at that time was mixed. Both sides feared an invasion by the other, a fear that was occasionally realized, as in the example of Oglethorpe's invasion. However, both sides also came to depend on each other for illicit trade. Spain often neglected to send her annual subsidy to Spanish Florida, for example in 1739, 1740, 1741, and 1745. Efforts to raise crops around St. Augustine seldom produced enough for the settlers to live on, and the Spanish governor could not depend on Cuban foodstuffs, much of which was expensive and spoiled. So St. Augustine had to consort with the enemy, the British, for survival. In exchange for gold and silver and Florida-grown oranges, the people of St. Augustine received from the British much-needed foodstuffs.

The Spanish government, like many European governments, considered her colonies, including the one in north Florida, as existing solely for the purpose of helping the mother country. Trading with other countries would make the colony less dependent on the mother country and would send to the "enemy" money that otherwise would have gone back to Spain. The strict Spanish trade laws forbade such trade with the enemy, but the Spanish in St. Augustine depended on it for survival. As much as the local Spanish authorities would have liked to obey the mother country's laws in that regard, they simply could not; for example, when they realized they had to supply food to a large contingent of Cuban reinforcements that arrived in 1740.

A 1670 treaty did permit colonies to aid British ships that reached Spanish-American ports in trouble, so British ships pretended to be in dire straits and in need of provisions or repairs when they reached those ports. Once they were in port, the British crews would then sell what merchandise they had. In this way the British were able to skirt the law and appease local Spanish officials. And the local St. Augustinians were able to buy much-needed pork, beef, wine, salt, flour, and other foodstuffs from the British vessels.

When open hostility broke out between England and Spain, conditions changed dramatically. In order to survive, Spanish privateers out of St. Augustine preyed on British shipping. With economic ties to Charleston cut off and the British ships preventing trade with Cuba and Mexico, those privateers provided the town with essential food and supplies. In the 1740s and 1750s, Menéndez, like many fellow residents of St. Augustine and many British residents of the Carolinas, became a privateer or pirate, depending on who was doing the labeling. He was able to use the port at St. Augustine as a convenient base out of which to sail and to return with supplies. Menéndez was able to recruit a number of volunteers from among the blacks at Fort Mose to man the ships used to intercept foreign vessels (see picture).

Menéndez and the other blacks knew they would be in deep trouble if they were captured on the high seas. If other pirates captured them, the pirates might allot them as slaves to crew members injured in battle; for example, a pirate who lost his right arm in a battle could receive six slaves; if he lost one eye, he could receive one slave, etc. If the British cap-

tured the blacks at sea, the British might claim that the blacks were slaves and sell them for profit. Menéndez's fear was realized in July 1741 when the British ship *Revenge* overtook a Spanish ship and found him on board. He knew he was in deep trouble.

To retaliate for what the British claimed was the castration of British prisoners at Fort Mose, the sailors tied Menéndez to a gun and brought forth their doctor, who was told to threaten to castrate the pirate. Menéndez claimed that the Indians had performed the atrocities at Fort Mose and that he was a pirate only because he wanted to reach Havana and then Spain to seek some monetary compensation for his bravery. Others on board his ship, including whites and blacks, corroborated Menéndez's story. The British may have believed him, but they wanted to punish him for being a pirate. They gave him 200 lashes and pickled him; that is, rubbed salt or salt and vinegar onto his back to make him suffer even more.

When the *Revenge* landed in the Bahamas the following month, the commander of the ship, knowing full well that he would get the largest share of whatever prize money he and his crew could claim, went before the Admiralty Court and tried to convince its members that the blacks should be condemned as slaves. He called Menéndez "that Cursed Seed of Cain. Curst from the foundation of the world, who has the Impudence to Come into this Court and plead that he is free. Slavery is too Good for such a Savage, nay all the Cruelty invented by man...the torments of the World to Come will not suffice." The commander's words must have had an effect on the Admiralty Court because it ordered that Menéndez be sold as a slave.

What happened after that we do not know. However, by 1752 Menéndez was once again in command of his followers at Fort Mose. He either escaped from the British or from slavery or worked out his freedom somehow. In any case, he was a very resource-ful man and one that slavery could not subdue. He and the other free blacks of Fort Mose stayed in north Florida until 1763, when Spain ceded Florida to England. Before the British moved in for their 20-year stay, the Spanish left for Cuba, taking with them the blacks who had served them so well at Fort Mose. Menéndez and the other blacks settled, first in Matanzas, Cuba, and later in Havana.

Even when the Spanish recovered Florida in 1783 and resettled many of its citizens in St. Augustine, Fort Mose was not reestablished as the free black town it had been. Francisco Menéndez — the ex-slave who served his Spanish masters so loyally, the pirate whom the British captured and sold into slavery, the staunch leader of the colonial South's only free black town — passed into history as one of the area's early leaders. To the British he was a pirate; to the Spanish he was an important ally in their fight with the Indians and British; to the other blacks of Fort Mose he was a leader and strong role model.

FURTHER READING:

Kathleen A. Deagan, "Fort Mose: America's First Free Black Community." *Spanish Pathways in Florida*, edited by Ann L. Henderson and Gary R. Mormino. Sarasota: Pineapple Press, 1991, pp. 188-203.

Joyce Elizabeth Harman, *Trade and Privateering in Spanish Florida, 1732-1763*. St. Augustine, Fla.: The St. Augustine Historical Society, 1969.

Jane Landers, "Black Frontier Settlements in Spanish Colonial Florida." *Magazine of History* (Spring 1988), pp. 28-29.

Jane Landers, "Gracia Real de Santa Teresa de Mose: A Free Black Town in Spanish Colonial Florida." *The American Historical Review* (February 1990), pp. 9-30.

"The Mose Site," *El Escribano* (April 1973), pp. 50-62.

John Jay TePaske, *The Governorship of Spanish Florida, 1700-1763*. Durham, N.C.: Duke University Press, 1964.

CHAPTER 11

JOSÉ GASPAR, 1800

This chapter could be subtitled "The Pirate Who Did Not Exist" or "The Nonexistent Pirate Who Spawned an Industry." This is the story of one John Gomez, who may have been a real-life pirate and who may also have invented one of Florida's most famous pirates. His murky background and intriguing stories were just what a newspaper columnist needed to promote what has become the state's most successful pirate festival.

Gomez was born in 1778, possibly on the Portuguese island of Madeira. His family moved to Spain and later to France, from which Gomez sailed as a teenager to America. After landing in South Carolina, Gomez went south to St. Augustine, where he signed on another ship. When that ship was at sea, the pirate José Gaspar seized it, according to Gomez (see picture); again, much of this story came from Gomez. Gaspar made Gomez a cabin boy, but the boy liked the life of the pirates so much that he gradually rose in rank until he became a pirate himself. Whether Gomez willingly became a pirate or was forced to do so under the threat of being tossed overboard is not clear. At their trials after they were captured, pirates would invariably claim that they had been forced to become pirates or be killed.

Why a sailor like Gomez would join the pirates tells us much of shipboard conditions in the 18th century. The low wages paid sailors could not compare with the possible riches a band of pirates could quickly amass. Pirate captains did not usually pay their crew any wages, but instead promised them a share of the booty captured on the high seas. A pirate captain would be allowed under the ship's articles to have a share-and-a-half, and each sailor would have a full share of the booty. Also, if a pirate were to lose a limb during an attack, he might earn as much as 800 pieces of eight; if he lost a joint, he would earn half that.

A pirate would swear to these articles with his hand on a Bible or, if none were present on board, on a hatchet. The written articles, which would govern the conduct of all on the ship, were strict. They were necessary in order to maintain strict discipline on the ship. Even if the pirates could not read or write, as was often the case, they still insisted on these written articles. They had seen or experienced the power of written documents while they were ordinary civilians on land and therefore wanted such documents to control their lives and practices at sea.

The captain of a pirate ship might be the bravest or strongest or most clever among the crew, but such a position did not usually last very long. The pirates would elect their leader and dismiss him if he displeased the crew or was unsuccessful in raids. While the crew might kill a captain who had fallen out of favor, they would more often maroon him or send him off in a small boat with some provisions, especially if he had been a popular commander before he fell into disrepute.

As a kind of check to a captain who had grand illusions of absolute power, the pirates would often make the ship's quartermaster much more impor-

tant than was true on ships of the royal navy. The quartermaster was the one who took charge of the helm when the ship was engaged in battle. His experience in navigation and discipline gave him a prestige that allowed him to determine the value of booty, to dole out the shares after a successful attack, to settle arguments between crew members, even to measure off the 20 paces of two pirates determined to duel it out.

In contrast to popular stories and movies, a pirate captain had few perks. He usually ate the same meal as his crew and at the same table. Some of the leaders, like Captain Bartholomew Roberts, drank nothing stronger than tea and would not allow gambling or women on board his ships. Most of them, however, were not such teetotalers and would join their men in drunken bouts after successful raids. Drunkenness, in fact, became one of the few ways that the pirates could forget their sorry lot and the fact that they would never return alive to their homelands. While novelists and scriptwriters have glamorized the life of the pirate, in reality that life was very hard and usually very short.

In any case, Gomez joined the pirates under the leadership of Gaspar, a clever man who supposedly in just 11 short years captured and sank 36 ships, including the French ship *Orleans* with its $40,000 cargo. Gaspar (or Gasparilla as he was sometimes called) had his headquarters on Gasparilla Island near Fort Myers. Commodore David Porter's U.S. Naval Squadron finally eradicated pirates from the Gulf Caribbean in the early 1820s, including the despicable Gaspar.

According to legend, Porter ended Gaspar's days by disguising a U.S. warship to resemble a large, lumbering British merchantman. When the pirate ship approached to board the "merchantman," Porter's troops revealed themselves and quickly overcame the pirates. Gaspar, realizing his pirate days were over and not wishing to end his days on the gallows, wrapped an anchor chain around his body, shouted something like "Gasparilla dies by his own hand, not the enemy's," jumped into the sea, and drowned.

Porter's crew captured other crew members of the pirate ship and hanged them, but Gomez and several others managed to swim to nearby Gasparilla Island and then on to the mainland and the Everglades. After wandering through Florida and even

settling down with a widow until the 1850s, Gomez found a permanent home in the wild Ten Thousand Islands south of Fort Myers. He finally settled on Panther Key, which later became Gomez Key, 15 miles from Marco Island. People in Fort Myers called him "Old John, the last of the pirates," but he was content to fish and hunt and not bother anyone. In 1900, at age 122 (possibly the oldest person in America at that time), he drowned while fishing for mullet and thereby ended a life full of legends and adventures. It seemed somehow appropriate that he die in the sea which he had lived on for so long.

Gaspar might have remained a shadowy pirate from the distant past were it not for a press agent and the city of Tampa. The press agent for the Charlotte Harbor and Northern Railroad Company of Florida, wanting to attract more tourists to the Charlotte Harbor area, printed Gomez's story, perhaps embellishing it just a bit to emphasize the piratical element. For example, the press agent wrote that Gaspar had been a Spanish sailor who had fallen out of favor with his commander over a woman, left the navy, and became a pirate, eventually making his way to the Fort Myers area. That pamphlet became the "authority" for several books on pirates that claimed that Gasparilla was a real pirate. The power of the printed word!

Around the time of the press agent's brochure, a *Tampa Tribune* columnist, needing something to spice up Tampa's second May Day Festival in 1904, decided to use the legendary pirate Gaspar in the parade planned for the day. People enjoyed dressing up as pirates and becoming an "outlaw" for a day, and the Gasparilla Festival grew until now it lasts a month and includes an "invasion" of Tampa each February and a golf tournament, parties, and festivities, all of which bring much money into the city.

Local legends grew up to bolster the claims about Gaspar. For example, Captiva Island was supposed to have been named after the captive Mexican girls that the pirate kept there in 1801. The pirates had captured 11 beautiful girls on their way to Spain and kept them on this island for safekeeping. When Gaspar captured a particularly beautiful maiden by the name of Joseffa, the other girls became jealous, so Gaspar had to isolate Joseffa on a nearby island; local pronunciation eventually changed that island

to Useppa. Skeptics point out that Gasparilla Island was so named long before the pirate Gaspar, possibly after a Friar Gaspar, but that does not deter pirate hunters.

But the Gaspar legend also has a dark side to it. So many people believed that the pirate and his cohorts buried treasure on the islands around Charlotte Harbor that they have torn up archaeological sites looking for it. They have bulldozed Indian mounds, damaged valuable wetlands, and destroyed mangroves in their determination to find gold and silver. Urged on by treasure maps supposedly showing the exact location of the treasure and by such articles entitled "The Search for a $30,000,000 Treasure," they did irreparable damage to many sites around Charlotte Harbor. Finally, in 1992, authorities arrested four men for destroying sites on Big Mound Key and Hog Island.

One other point about John Gomez the pirate. Gloria Jahoda, in her *River of the Golden Ibis*, mentioned him in reference to Odet Phillippe, a Frenchman of royal blood whom Napoleon appointed a surgeon in the French fleet. Phillippe later made his way to south Florida, where John Gomez's pirate band captured him at sea. When they found he was a doctor, the pirates forced him to tend their sick comrades, whom he cured. They then let Phillippe go, and he returned to Indian River country.

When Phillippe was out on the ocean again, the same pirate band captured him and once again made him minister to their sick. When he cured them for the second time, the grateful John Gomez, perhaps wishing to keep Phillippe out of the hands of other, less savory pirates, told him of the beauty of the Tampa Bay area: "If there is a God, surely this is his resting place. There is but one bay to compare with it — Naples. I have seen waters all over the world and you can find no place like it." Phillippe was so intrigued by Gomez's description that he moved to Tampa Bay's Safety Harbor near what is now Phillippe Park. His orange groves became famous, as were his pool halls and bowling alleys. And all

because of a recommendation from the pirate John Gomez.

Whether Gaspar ever existed is not important to many if not most of the people of Tampa, a city whose professional football team is called the Tampa Bay Buccaneers. The term "buccaneer" was used for those who attacked Spanish ships in the New World in the 17th and 18th centuries. They originated on the island of Santo Domingo (Hispaniola) in the Caribbean. The sailors who settled there used to hunt the wild cattle on the island and dry it on wooden frames the Indians called "boucans," hence the word "buccaneer."

FURTHER READING:

Jack Beater, *The "Gasparilla" Story*. Fort Myers: Wordshop House, 1952.

Jack Beater, *The Life and Times of Gasparilla*. Fort Myers: Beater, 1968.

Jack Beater, *Pirates and Buried Treasure on Florida Islands, Including the Gasparilla Story*. St. Petersburg: Great Outdoors Publishing Co., 1959.

Karl A. Bickel, *The Mangrove Coast: The Story of the West Coast of Florida*. New York: Coward-McCann, 1942, pp. 99-110.

Bertha E. Bloodworth and Alton C. Morris, *Places in the Sun: The History and Romance of Florida Place-Names*. Gainesville: University Presses of Florida, 1978, pp. 55-57.

Gene Burnett, "Panther Key John Died Accidentally at 122 Years, Leaving Behind a Legend." *Florida Trend* (April 1979): 175-78. Reprinted in Gene M. Burnett, *Florida's Past*. Sarasota: Pineapple Press, 1988, vol. 2, pp. 95-99.

Karl H. Grismer, *The Story of Fort Myers*. St. Petersburg: St. Petersburg Printing Company, 1949, pp. 43-46.

William B. and E.R. Hartley, "The Search for a $30,000,000 Treasure." *Argosy* (May 1959): 19-21+.

Gloria Jahoda, *River of the Golden Ibis*. New York: Holt, Rinehart and Winston, 1973, pp. 112-14.

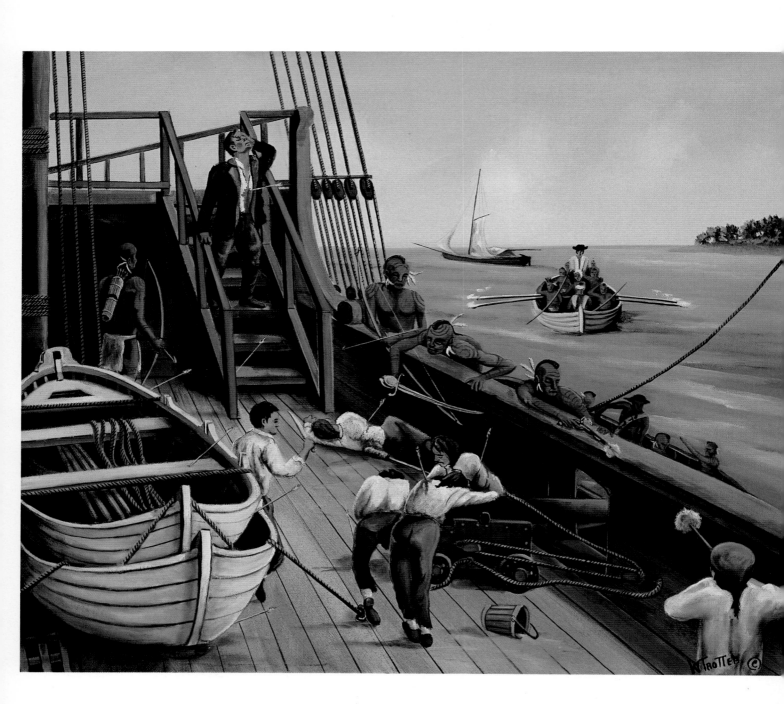

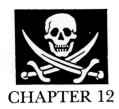

CHAPTER 12

WILLIAM AUGUSTUS BOWLES, 1801

Whether people admired or despised William Augustus Bowles, they certainly had to notice him. And notice him they did, calling him "vagabond," "beloved warrior," "desperado," "General," "desperate vile adventurer" and "Director General." He was a man equally at ease living among the Creek Indians in Florida's Panhandle or hobnobbing with English lords and ladies in London. Although he ended his life in a dingy prison at a young age, he had a career that few in our state's history have ever matched in terms of excitement, glamour, and danger.

Born in Maryland in 1763, Bowles ran away from home at the age of 13 and fought on the British side during the American Revolution. While stationed with British forces in Pensacola, Florida, he was declared AWOL and decommissioned when he missed a boat that was returning to camp. Unwilling to beg his superiors for forgiveness and fed up with army regulations, he defiantly tossed his soldier's coat into Pensacola Bay and headed into the wilderness.

The Lower Creek Indians who were camped nearby took the penniless youngster in and, after recognizing his skill and bravery, soon made him a member of their tribe, even giving him an Indian princess for a bride. He learned their language, adopted their customs, and began formulating plans for an Indian confederacy that would challenge the might of Spain and the United States. His physical skills and courage earned him the respect of the Indians, who called him "beloved warrior," and he slowly took on more and more leadership roles among them. Opportunistic whenever he could be, he actually enlisted his Creek Indians in 1781 to help the British defend Pensacola from the Spanish, for which the British restored his commission. But by that point he had higher ambitions.

When England and Spain signed a peace treaty in 1783 restoring Florida to Spain, Bowles began to concoct the idea of organizing the Florida Indians into an autonomous nation. The Spanish recognized what a threat he was and put a price of $6,000 and 1,500 kegs of rum for his capture. His Creek allies, spurning the Spanish offer, instead elected Bowles their commander-in-chief. Realizing he needed the help of a powerful ally, he took five Indians — dressed in full regalia — to London, where the British gave him a ship, supplies, and money to further his aims.

When Bowles returned to Florida, he taught his Indian allies the piratical tactics of attacking ships on the high seas (see picture). They captured several ships belonging to the wealthy trading firm of William Panton and John Leslie, two British loyalists that Bowles detested because of their monopoly on much trade in the Florida Panhandle and because of their shoddy treatment of the Indians. The Spanish continued their efforts to capture him and once, when he let down his guard a little in conferring with them under a white flag of truce, they arrested him and shipped him off to prison in Cuba, Spain, and then the Philippines. The Spanish thought they had seen the last of him in Florida.

But two years later, Bowles escaped and made his way to England, where powerful British friends once again outfitted him for his Florida adventure. When he returned to Florida in 1799, he organized the Muskogees, Creeks, Cherokees, and other Indians into the State of Muskogee and declared war against his old enemy, Spain. Bowles established the capital of Muskogee in Mikasuke, a Seminole village near Tallahassee. He also designed a national flag and adopted "God save the State of Muskogee" as the official motto of his new nation.

He extolled the virtues of the new state in advertisements he placed in the *Nassau Gazette*, but the few farmers and artisans whom the ads induced to go to northern Florida were disappointed at how poor the conditions there were for establishing a business. The few businessmen who showed up in Muskogee realized what a mistake they had made. Fearful of being killed if the Indians caught them leaving, as they thought had happened to other white men, the businessmen managed to escape and made their way to safe refuge at the Spanish fort at San Marcos de Apalache. That fort became the focus of Bowles's attack when, after his declaration of war against Spain, he led his makeshift army and captured the fort, which had been the scene of an earlier pirate raid (see Chapter 4). Five weeks later the Spanish recaptured their fort, but still realized what a threat Bowles's new Indian nation was.

Besides an army, Bowles also needed a small navy to prey on Spanish shipping in the Gulf. The Muskogee nation's declaration of war on Spain allowed Bowles to issue privateer commissions and to attract sailors interested in earning money fast. In 1802, he commissioned a privateer, the *Muskogee Micco* (*Muskogee Chief*), under its owner, a Captain Johnson of New Providence. The privateer, or "pirate ship" as the Spanish saw it, captured two Spanish ships in the Gulf and took them to the Apalachicola River to rearm them for use in the Muskogee navy. Bowles commissioned another schooner, the *Favorite*, in the Bahamas, but, as it sailed to Apalachicola with cannon that he planned to put into the prizes he captured, the Spanish seized it and took it to their fort at St. Marks.

Bowles's navy, consisting of several small vessels sailing as privateers from headquarters on St. George Island, was under the command of Richard Powers,

the "Senior Officer of Marine of the State of Muskogee." The speedy, lightly armed vessels were able to dart out into the Gulf after a solitary Spanish merchant ship and capture it or at least harass it. Their seizure of Spanish shipping caused much aggravation to the Spanish, who called Bowles and his followers a "nest of pirates." The privateer crews that Bowles had at his disposal consisted of several nationalities (English, Spanish, African-American, and Indians), but their captains were Englishmen from the Bahamas. It took strict rules and their enforcement to keep order in the polyglot crews, although the rules definitely favored the English. For example, a court-martial found a Spanish sailor guilty of attempted desertion, while one of the English captains, who had killed another officer, was absolved of any wrongdoing.

What induced the privateers to join Bowles was the money they hoped to earn from a very liberal policy of privateers' commissions: the captain and crew would get two-thirds of the booty while Bowles's state would keep only one-third. The booty that the privateers brought in for Bowles enabled him to keep a good supply of goods and to maintain the loyalty of his Indian troops — at least for a while.

The Spanish galleys, which might be expected to protect passing Spanish merchant ships, could not venture too far out into the Gulf because that would expose the Spanish fort at St. Marks to possible capture by Bowles with a land force. The restricted movements of the Spanish galleys gave more freedom to the Muskogee privateers, who could roam almost at will in the Gulf.

Once Spain and England stopped fighting with each other, Bowles was in deep trouble. As pointed out by historian J. Leitch Wright, Jr., "the distinction between privateer and pirate frequently was a thin one in the West Indies, and Spain from the beginning considered Muskogee seamen pirates" (p. 156). When Spain began treating the captured privateers as pirates, and when the British government at Nassau also did that, especially after one of the privateers captured a British ship, the days of the Muskogee navy were numbered. The British, who had supported Bowles up to that point, began arresting his privateers when they landed in Nassau, tried them for piracy, and executed several of them. That effectively ended the Muskogee navy and the

attacks on Spanish ships by the privateers/pirates of Bowles.

Spain was no longer at war with England and seemed willing to join forces with the United States to rid the Gulf of Bowles, who was causing much trouble for both nations in the area. Authorities lured Bowles in 1803 to a conference in Alabama where he was to represent his tribe in negotiations. The town where the conference took place was a "peace town," where Indian law forbade the use of weapons, and that may have induced Bowles to believe he was safe. He may have suspected a trap, since he had learned not to trust the Spanish from his capture by them under a white flag of truce, but he was used to doing the unexpected and to taking chances. He hoped to persuade the Indians one more time that their best fortunes lay with him, but it was not to be.

Some renegade Indians, hoping for a reward promised to anyone who would capture Bowles, seized him and handed him over to the Spanish, who quickly transported him to the prison of Morro Castle in Havana, Cuba. There he must have realized that his dreams of a Muskogee Nation were over and that he would never return to his beloved Florida. He still had his pride, however, and refused a visit by an official with the words: "I am sunk low indeed but not so low as to receive the Governor General of Cuba."

In the end he decided to die in his own way rather than in the slow degradation of prison. He simply refused to eat and died in 1805 in his early 40s. He accomplished much, but also caused much pain and suffering to many Indians and Spanish alike. The fact that Spain had to rely on duplicity and bribes to capture Bowles pointed out how impotent she was in Florida and led to the eventual takeover of the territory by Americans and to the withdrawal of the Spanish from the area.

One of the most colorful figures to live in Florida before the United States took control of the peninsula from Spain in 1821, William Augustus Bowles played a role in the land and sea history of the Panhandle. His plan of establishing an independent Indian nation on the southern border of the United States in a territory that Americans were lusting after was an improbable one and doomed to fail, but he still hoped that luck and the changing European alliances might help him. As he pondered his future and the collapse of his Indian nation, he might have hoped to die on the high seas leading a pirate raid or on land fighting the despised Spanish rather than in a dingy prison abandoned by those he had tried to lead. In any case, he added a chapter to Florida history that was rich in action, ambition, and dreams.

FURTHER READING:

William S. Coker and Thomas D. Watson, *Indian Traders of the Southeastern Spanish Borderlands.* Pensacola: University of West Florida Press, 1986, pp. 112-365.

Duvon C. Corbitt and John Tate Lanning, editors, "A Letter of Marque Issued by William Augustus Bowles as Director General of the State of Muskogee." *The Journal of Southern History*, vol. 11 (May 1945), pp. 246-61.

Elisha P. Douglass, "The Adventurer Bowles." *The William and Mary Quarterly*, third series, vol. 6 (January 1949), pp. 2-23.

Lyle N. McAlister, editor, "The Marine Forces of William Augustus Bowles and His 'State of Muskogee.'" *The Florida Historical Quarterly*, vol. 32 (July 1953), pp. 3-27.

Lyle N. McAlister, "William Augustus Bowles and the State of Muskogee." *The Florida Historical Quarterly*, vol. 40 (April 1962), pp. 317-28.

Joseph Millard, *The Incredible William Bowles.* Philadelphia: Chilton Books, 1966.

J. Leitch Wright, Jr. *William Augustus Bowles: Director General of the Creek Nation.* Athens: University of Georgia Press, 1967.

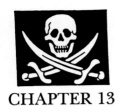

CHAPTER 13

ℒUIS AURY, 1817

In 1808, when the United States outlawed the importing of slaves, smugglers looked to the territory of Florida as a means to bypass the law. Florida technically was still controlled by Spain, but the inability or unwillingness of that country to control the peninsula made it like a sieve for smugglers, brigands, and pirates who used its long coast as an entry port. The many inlets along Florida's east coast made it difficult to detect the small boats used by these criminals, as drug smugglers have found out in this century.

Fernandina, on the upper northeast coast of Florida, became the conduit through which smugglers took into the United States all kinds of contraband, including slaves. Pirates found the bustling port a natural choice for smuggling and selling seized goods or seeking a friendly town for resting between raids. One man in particular used Fernandina for much of his piratical episodes: Louis Aury.

Born Louis-Michel Avery in Paris, France, around 1788, young Aury joined the French navy in his mid-teens and served on a warship and then on privateers. After seven years of service, he had earned several thousand dollars in prize money and the rank of lieutenant. In 1810, he spent $4,500 of his money to buy a schooner in New Orleans, but American officials seized it, claiming it was a privateer. Angered at what he considered an injustice, Aury bought part of a Swedish schooner, armed it at sea, renamed it *Vengeance*, and made plans to raid ships, including American ones. In 1811, when the ship

docked in Savannah, Georgia, a group of Americans destroyed it by fire. Again, Aury was outraged at the Americans and vowed revenge.

The following year, Aury was commanding the *Whiting*, a French privateer that had been a British schooner. He was officially a privateer for the country of Cartagena (modern-day Columbia) and used his papers to capture Spanish ships. He became commodore of the Cartagena fleet, armed more vessels, and shared in the booty that his ships brought back. The Spanish retaliated by attacking Cartagena, which forced Aury to defend the city. He did well until he ran out of gunpowder, at which point he had to retreat.

To help the local people evacuate the city, Aury provisioned 13 ships in December 1815 and packed 2,000 escapees on board for the one-week trip to Haiti. They escaped the Spanish blockade, but a huge gale scattered the ships and drowned many of the passengers. Only a few hundred survivors managed to reach Haiti, and many blamed Aury for the heavy losses. His luck seemed to be consistently bad.

Simón Bolívar at that time was engaged in the battle to make Venezuela free, but Aury, who might have joined Bolívar in the fight for South American independence, chose instead to leave the area and sail under the flag of Mexican rebels to wreak havoc in the Gulf of Mexico. There his ships captured and destroyed several Spanish ships after looting them of food, wine, and textiles. When Aury and his recruits from Haiti stopped in Galveston on their way

to attack a Mexican port, they mutinied, stabbed Aury in the chest, stole three ships, and sailed back to Haiti with thousands of dollars of his booty. Aury recovered and resumed his piratical ways, attacking vessels in the Gulf of Mexico and stealing much of their cargo.

Meanwhile in Florida, Sir Gregor MacGregor, a Scottish mercenary supported by American businessmen, took over Amelia Island at the northeastern tip of Florida in 1817 and successfully fought the Spanish. In August 1817, 100 ex-officers of the British armed forces left England for South America, where they hoped to join the fight for independence. When they arrived in the West Indies, they heard that MacGregor had captured Amelia Island from the Spanish, and 30 of the British ex-officers decided to join him in Florida. Aury also saw an opportunity in helping MacGregor and sailed to Fernandina in September 1817. There, according to some authorities, he decided not to attack the town from the sea, but instead to surprise it by a rear attack. He took his forces inland and had them sneak up on the town through the swamp (see picture). When the townspeople spotted the pirates approaching through the swamp, they thought they must be surrounded and quickly surrendered.

Once in the town, Aury became commander-in-chief of the newly installed military and naval forces there and, on September 20, issued the following proclamation:

> The inhabitants of the Island of Amelia are informed, that tomorrow the Mexican flag will be hoisted on the fort with the usual formalities. They are invited to return as soon as possible to their homes, or send persons in their confidence to take possession of the property existing in the houses, which is held sacred. All persons desirous of recovering their property are invited to send written orders, without which nothing will be allowed to be embarked.
>
> Proclamations for the organization of the place will immediately be issued.

The next day Aury, claiming to be an officer of Mexico, raised the flag of the Mexican Republic and annexed Amelia Island to Mexico.

Many local inhabitants left the island when Aury and his pirates took over. They chose not to join his motley crew, many of whom were less interested in political establishments or in helping South American countries become free than they were in looting and pirating. Aury's pirate band discovered what many military commanders have learned: that it is easier to conquer a place than to rule it successfully and harmoniously. The constant bickering and fighting among Aury's forces kept the town in a turmoil until he could establish martial law.

Aury's troops, which included 130 mulattoes known as "Aury's blacks," constantly feuded with local American forces. By the time the ex-officers of the British armed forces arrived in Fernandina from the West Indies in October 1817, MacGregor had left and Aury informed them that he already had too many officers and did not need them. Choosing not to do the menial tasks that Aury wanted them to do, most of the British ex-officers left the island for more promising lands.

Aury then decided to take complete charge of the town. He brought his privateers to the waterfront, had them aim their guns at Fernandina, declared himself the supreme military and civil authority in the place, and imposed martial law on the citizens. Once in power, he took steps to eliminate his rivals. He banished some of the Americans who had caused him trouble and demanded that they not settle south of North Carolina. He arrested some of the British ex-officers and began proceedings to court-martial them; the hearing officials, whom Aury had hand-picked, were other pirates loyal to him. After hearing the evidence, they declared the defendants guilty and sentenced them to death. The defense lawyer, himself an ex-British officer, threatened the pirates with death by British forces if the pirates insisted on carrying out the death penalty on the ex-officers. The pirates thought the British just might attack them, so they reconsidered and changed the sentence to banishment from the island.

Before Aury's takeover, privateers had tried to use Fernandina as a place to unload their booty from captured ships, but were appalled at the chaos there. They took their booty to friendlier places like Baltimore and New York. When Aury finally brought some order to the place through the imposition of martial law, privateers brought their prizes into port and sold them to willing buyers.

Those prizes included shiploads of African slaves, a source of cheap labor that slave owners in the South were desperate to buy. In order to avoid the American revenue officers at the entrance to the harbor, the pirates would take their African slaves 50 miles up the St. Marys River and sell them to eager plantation owners in Georgia. In two months alone, the pirates were able to sell more than 1,000 slaves to those planters. Aury's men also captured runaway slaves, and, unlike the Spanish who had welcomed such slaves to freedom in the 18th century, the pirates resold the slaves to willing buyers. By this time the American government was determined to end the smuggling and selling of slaves in Florida.

To hold off attempts by the U.S. government to take over Amelia Island and to give the semblance of a legitimate government there, Aury had his pirates hold an election for a legislature. Before the free inhabitants could vote, they had to take the following oath:

I swear that I will truly and faithfully and as far as it is in my power support the cause of the Republic of the Floridas against its enemies. I renounce all allegiance to any State not actually struggling for the emancipation of Spanish America. So help me God.

After the election and establishment of the legislature, delegates set up a committee to draft a constitution for the "Republic of the Floridas."

By that time President Monroe had had enough of Aury and decided to expel him and his troops from Florida. Aury, realizing that his occupation of Amelia Island would soon end and unable to escape just then because his ships were in such poor condition, spent some time trying to justify his actions, but few people would believe him. He realized he had to give up his grandiose plans for Amelia. Late in 1817, he surrendered to the Americans, who then raised the American flag on Amelia Island. They detained him only two months and then let him go free.

The U.S. Congress passed new laws that imposed heavy penalties on those convicted of illegally importing slaves into the United States, including making slaving an act of piracy. Patrol boats were to cruise the coast of Florida to intercept any slavers. Also, Congress authorized President Monroe to take over Florida and to appoint honest officials. But Aury was far away by that point.

Early in 1818, Aury, determined to fight the Spanish in South America and hoping for a change of fortune, had left Amelia on an ill-fated attempt to make Colombia independent. But once again bad luck hounded him. Many factors contributed to the failure of his latest project, including a devastating hurricane, famine, fever, and mutiny. His troops attacked the Spanish in Honduras and other sites, but in the end Aury failed in his plans for liberating countries from the Spanish. He died in 1821, at around 33 years, after being thrown from a horse, an ignominious death for one constantly bedeviled by misfortune. The pirate who ruled Amelia Island from September 21 to December 23, 1817, had little to show for his many years of pirating.

FURTHER READING:

T. Frederick Davis, *MacGregor's Invasion of Florida, 1817.* Jacksonville: Florida Historical Society, 1928.

Stanley Faye, "Commodore Aury," *The Louisiana Historical Quarterly* (July 1941), pp. 611-697.

CHAPTER 14

\mathcal{P}IRATES IN THE FLORIDA KEYS, 1819

Indians or wreckers near Indian Key in November 1822 would have seen a common sight in those days: the foundering of a ship on the Florida Reef. The U.S. schooner *Alligator* was returning from a trip to the coast of Cuba, where she had captured several pirate ships but had lost her captain, Lt. William Allen, from wounds suffered in the battle. When the *Alligator* ran aground on the Florida Reef, her commander ordered his crew to destroy the ship to keep her out of the hands of the pirates who used the area for hiding.

The Florida Keys were known then for a free-spiritedness, a lawlessness, and a disregard for social conventions. Located at the southeastern tip of the United States and connected today by a two-lane highway that hurricanes can easily wipe out, the Keys have attracted their share of loners and adventurers, eccentrics and malcontents. In the late 1700s and early 1800s, that isolation was even more pronounced since no pesticides controlled the mosquitoes, no railroad made communication between the Keys easy, and no road connected the islands.

But this isolation was just what the pirates preferred as they serviced their ships and hid from patrol boats. And the countless hidden bays and protected coves provided ideal places for pirates to conceal themselves until they could dash out to attack a passing ship (see picture). Even when federal forces found the pirates and gave chase, the shallow-drafted boats of the pirates could easily escape the larger, slower boats of their pursuers.

The Keys also offered a safe place for careening: tilting a vessel on one side to make the other side accessible for repairs or cleaning. Periodically, the pirates would beach their ships on the sandy shore of a secluded island, unload the heavy cannon and cargo, tip over the ship for scraping and sheathing (reinforcing the bottom of the ships with double timbers to keep off the worms), coat the bottom with tar and tallow for more speed and protection, and finish the operation before federal forces could find them. Cleaning the wooden hulls of the marine growth that slowed the ships down and hastened their decay and ridding the ships' bottoms of the deadly teredo worm that chewed on the wooden vessels and caused sinking or leaking were tedious chores, but necessary for survival.

As Spain slowly lost control of La Florida, and before the United States and gained control in 1821, pirates used the Keys with impunity, confident the Spanish were too weak to stop the piratical attacks on commerce. The *Niles' Weekly Register* on April 19, 1823 (p. 98), for example, reported more than 3,000 acts of piracy from 1815 to 1823 in the West Indies and off the Florida coast. The end of the War of 1812 and then of the Napoleonic Wars in 1815 resulted in peace in Europe and the United States, but Spain's New World colonies began to seethe with a desire to be free. In the first quarter of the nineteenth century, many Spanish colonies in South America earned their independence, as did Spanish Florida.

Those fledgling would-be nations were not powerful enough to challenge Spanish ships on the high seas, but instead had to rely on mercenary seamen called privateers. Seamen who found themselves unneeded by peacetime navies joined the privateers to use their skills for their own profits. Brigands and criminals eager to take advantage of Spanish incompetence on the sea joined the privateers to wreak havoc on the shipping lanes of the Caribbean. Sailing under the nominal flags of the Spanish colonies that were seeking independence, and armed with real or bogus letters of marque, those seamen ventured forth on the Atlantic Ocean or in the Gulf of Mexico to attack any ships that seemed weak, regardless of the victim's nationality.

Typical of the horror tales told by captives of such privateers/pirates was this one that the *Boston Daily Advertiser* (February 3, 1819, "Marine Journal") printed from the supercargo or commercial officer on board the *Emma Sophia*, a ship attacked off the Florida coast in December 1819 (see picture):

On Saturday 19 inst. [instance?] between the Bahama Bank and Key Sal Bank we were boarded and taken possession of by a small schr. [schooner] of about 30 tons, having one gun mounted on a pivot and 30 men. She manned us with twelve men, Spaniards, French, Germans and Americans, and carried us towards the Florida coast.... Every man had a knife about a foot long, which they brandished, swearing they would have money or something more valuable, that was concealed, or they would kill every soul of us, and they particularly threatened me. I appealed to their captain, told him I was in fear of my life, and went with him on board his privateer. He said he had no command, the crew would do as they pleased, that I need entertain no fear of my life, but had better tell at once if anything was concealed....

When they came on board, they said they had come to find where the gold etc. was, and that if we would not tell, they would hang every man of us and burn the ship. Davis, the spokesman, drew his knife and swore that every man should die, unless he found the money, and first he would hang the supercargo. He called for a rope, which he had brought on board, fitted with a hangman's noose, sent a man up to the mizzen yard and rove it [passed the rope through a hole] and brought the nook [noose] down — and one man held it, and another stood ready to hoist.

Now, said Davis, tell me where is the money, where are your diamonds, or I will hang you this minute. In vain I repeated I had nothing more but my watch, which I offered and he refused. Once more, said he, will you tell? I have nothing to tell, said I. On with the rope, said the villain, and hoist away. The fellow with the noose came towards me, and I sprang overboard. They took me up after some time, apparently insensible. They took off all my clothes, and laid me on my back on deck, naked as I was born, except having a blanket thrown over me. Here I laid five hours without moving hand or foot. Meanwhile they robbed us of every thing of the least value. Against me they seemed to have a particular spite, stealing even the ring from my finger and all my clothes from my trunks which they sent on board the privateer.

After these murderous threats and the looting of some $50,000 from the *Emma Sophia*, the pirates released the ship and sailed away. From such testimony one can see what fear and terror the pirates of the Keys inflicted on helpless victims.

When the United States acquired Florida in 1821, she determined to put an end to the pirates in southern Florida, especially in the Keys. The atrocities inflicted upon innocent passengers on ships caught by the pirates led the American public to demand an end to such piracy. What the federal government needed was, first, an effective commander to take charge of the anti-pirate forces and, second, shallow-draft vessels to pass over the Florida Reef and pursue the pirates into the waters around the Keys. In Commodore David Porter and his Mosquito Fleet she was to satisfy both needs.

President James Monroe asked the U.S. Congress to establish a squadron to rid the Keys of the pirates, and Congress appropriated $160,000 to set up a fleet of ships suitable for such a task. In December 1822, the Secretary of the Navy appointed Captain David Porter (1780-1843), a distinguished

naval officer, to command the fleet. Porter took command of a squadron made up of 16 ships, 133 guns, and 1,100 men. Among the ships were five 20-oar barges that drew such a small amount of water that they could pass over reefs and enter shallow bays. With names like *Gallinipper* (named after a large mosquito or other biting, stinging insect), *Gnat*, *Midge* (named after a very small gnat or fly), *Mosquito*, and *Sandfly*, the barges gave the name "Mosquito Fleet" to the squadron.

The Secretary of the Navy gave four orders to Porter: end piracy in the area, protect U.S. citizens and commerce, suppress the slave trade, and transport gold and silver from Mexico to the United States. On his way to setting up his headquarters in Key West, a strategic site that controlled the sea lanes passing from the Gulf of Mexico around the southern tip of Florida, Porter stopped in San Juan, Puerto Rico. The Spanish commander there did not want to allow Porter's ships to land because pirates had operated under the American flag the previous year and might be doing so again. He might have been trying to dissuade Porter from continuing on his pirate quest because, American authorities thought, some Spanish governors in the Caribbean were in collusion with the pirates and shared in their profits.

After Porter reached Key West, which was called Allenton in honor of Lt. William Allen, whom the pirates had killed, his West India Squadron spent much time acting as convoys for ships sailing along the coast and searching for the brigands. Although Key West had no good source of drinking water and had hordes of mosquitoes that spread yellow fever, Porter recognized its strategic importance when he wrote:

> The importance of this station appears daily more and more manifest to me, and, in my opinion, it is of but little consequence who possesses Cuba, if we keep a force here; for we have a complete command of the Gulf of Mexico, all the commerce of which, as well as that of Jamaica and Cuba, is completely at our mercy. It is almost incredible the number of vessels that daily pass and repass, and it is wonderful, considering the strong temptation, that piracy existed in no greater degree than it did.

Porter himself came down with yellow fever — for the third time in his life — but continued to praise the strategic importance of Key West.

Porter's squadron steamed out of Key West and began to rid the area, from Mexico to Cuba to the West Indies, of the infernal pirates, sometimes even pursuing them on land, where Porter's sailors discovered pirate families, including wives and children, all working together. Reports from the rapidly diminishing number of pirates testified to the speed and deadly artillery fire of Porter's shallow-draft Mosquito Fleet, which could pursue them into previously inaccessible coves. After several months of battling with the pirates, Porter claimed that "at present I have no knowledge of the existence of any piratical establishment, vessels, or boats, or of a pirate afloat in the West Indies or Gulf of Mexico. They have all been burned, taken, destroyed, or driven to the shore." Although the pirates returned from time to time, Porter's squadron was chiefly responsible for their demise.

Several other factors contributed to the disappearance of pirates from the Florida Keys. For example, the cooperation among the Americans, the British, and even the Spanish in Cuba and Puerto Rico made alliances between pirates and local authorities difficult to maintain, and the emerging new nations in South America no longer needed the privateers/pirates to prey on Spanish shipping. Commodore David Porter and his Mosquito Fleet had done their job and forced the pirates into prison, respectability, or other less-threatening areas. The Keys still attracted loners and eccentrics, but today the most dangerous residents in the hidden coves are sharks and barracudas.

FURTHER READING:

Michael Birkner, "The 'Foxardo Affair' Revisited: Porter, Pirates and the Problem of Civilian Authority in the Early Republic." *The American Neptune*, July 1982, pp. 165-178.

David F. Long, *Nothing Too Daring, A Biography of Commodore David Porter, 1780-1843*. Annapolis, Md.: United States Naval Institute, 1970.

David D. Porter, *Memoir of Commodore David Porter, of the United States Navy*. Albany, N.Y.: J. Munsell, 1875.

"Porter and the Pirates," *Martello*, Published by the Key West Art & Historical Society, No. 7 (1973).

CHAPTER 15

JEAN LAFITTE, 1819

Whether Jean Lafitte ever captured ships off Florida we cannot be sure. While Lafitte and his band spent most of their pirate career in Louisiana, they may have done some of their marauding off the west coast of Florida. What has persisted to the present are the rumors of Lafitte's buried treasure, even a ghost story, and the name of Lafitte is still associated with Florida sites as distant as Tavernier, Cedar Key, and Apalachicola.

As with so many pirates, we cannot be sure of Lafitte's early life. Jean Lafitte (or Laffite) seems to have been born around 1780, perhaps in Bayonne, France. He and his brother, Pierre, made their way to the New World and by 1810 were operating a blacksmith shop in New Orleans, but the shop was just a cover for smuggling operations. Their base of operations was on Barataria Bay south of New Orleans on the island of Grande Terre. The island was used by another pirate, Grambo, before Jean killed him in a dispute as to who would lead the pirates.

If the pirates under Lafitte were like most others, they came from the lower social classes, as did most seafaring men of the time. They seldom had wives or families, as evidenced by the fact that confessions on the gallows often had expressions of regret directed to the pirates' parents but not to any wives or children. Some pirate captains had a policy of not taking on any married men in order to forestall desertion and to encourage the crew to look on each other as "family." That togetherness also resulted in a democracy on the ship; whereas the commander of a navy ship might consult with his top officers before making a decision, all the pirates on a ship would be expected to take part in such decisions as where to seek prey and how to punish offenders among the crew.

Like other pirate leaders, Jean was a skilled polyglot, one who could speak several different languages fluently. Such a skill was necessary in a world that attracted men from different countries and different languages. The Lafitte brothers chose to be in Louisiana, partly because they spoke the same language, French, that many of the people there spoke, and partly because they liked the freedom and opportunities a frontier state offered.

Like the Lafittes, many pirates drifted to the Gulf of Mexico and its opportunities, especially when the war between France and Great Britain ended in 1815 and put thousands of sailors out of work. Many men chose to become pirates rather than poorly paid tradesmen working on the land. The pirates, many of whom served under Jean Lafitte, were a nasty lot. In his classic work, *The History of Piracy*, Philip Gosse described the new pirates in bleak terms:

> The earlier pirates, with all their black faults and their cruelty, were not without some trace of humanity, and on occasion could fight bravely. These new pirates were cowards without a single redeeming feature. Formed from the scum of the rebel navies of the revolted Spanish colonies and the riffraff of the West Indies, they were a set of

bloodthirsty savages, who never dared attack any but the weak, and had no more regard for innocent lives than a butcher has for his victims. (p. 213)

The Lafitte brothers and their band of pirates roamed the Gulf of Mexico preying on Spanish shipping and on slavers transporting slaves from Africa to southern and West Indian plantations. By selling the slaves to Louisiana planters at a dollar a pound and by selling their seized booty to willing shopkeepers in New Orleans, they became very rich. New Orleans at that time was close to the American frontier, and its mixture of enterprising Americans, independent Creole-born natives, and Choctaw Indians allowed piracy to thrive. So many people seemed to prosper on the pirates' loot being sold and resold that local authorities, especially those who also profited from that loot, did not crack down on the pirates.

Finally, however, local shipowners, tired of losing their cargoes to the pirates, had the Louisiana governor arrest the Lafittes and charge them with piracy, but by using clever lawyers they were found innocent and were freed.

At that time the United States was engaged in the War of 1812 with England. In 1814, a British warship captain who had heard about the Lafittes' problems with the local governor met with Jean and offered him $30,000 in gold if he would join the British in an attack on New Orleans. Instead of committing himself and his forces to help the British, Jean hesitated. He then informed the Louisiana governor about the British offer, but the governor refused Lafitte's offer of help for the city and instead attacked the pirate's stronghold at Barataria and destroyed it.

Lafitte then appealed directly to the U.S. military commander, Andrew Jackson, who accepted the pirate's offer to aid New Orleans. The help that Jean and his fellow pirates gave to Jackson in the Battle of New Orleans did much to ensure the American victory in January 1815. But with peace came a realization by the pirates that life in New Orleans would be different, that American control would bring law and order. Jean realized that the city would be less lawless and more constraining with a man like General Jackson in charge, so he and his brother regrouped their men and sailed to Galveston Island.

There they eventually set up a pirate stronghold with about 1,000 men and a dozen ships.

Lafitte prospered until 1819, when federal forces captured most of his pirate ships and made plans to capture the leaders. The U.S. *Enterprise* entered Galveston Bay intent on ending the pirates' reign and restoring a lawful society there. The commander, Lt. Laurence (or Lawrence) Kearney, met with Lafitte and ordered him to abandon the site. Jean realized that he could not match the firepower of the federal forces and made plans to escape rather than put up a useless resistance. He transported much of his movable booty into his ship, the *Pride*, burned down his fortress, and sailed away into obscurity. Although his death cannot be pinpointed, most believe that he died in the Yucatan peninsula around 1825.

Stories of buried treasure have inspired many Floridians to search any promising site for the treasure that the Lafittes supposedly buried here. *The Apalachicola Times*, on Nov. 2, 1935, printed a story about would-be treasure seekers digging around Apalachicola in a vain attempt to find the pirates' treasure. And Tavernier in the Florida Keys, along with Tavernier Creek and Tavernier Key, may commemorate a Frenchman named Tavernier, who was Lafitte's lieutenant.

Finally, a popular story about Seahorse Key in the Cedar Keys refers to Jean Lafitte. According to that story and local legend, the pirate had entrusted a treasure to a faithful comrade, Pierre LeBlanc. To help LeBlanc make his nightly rounds of the island, Lafitte also had given him a beautiful palomino from a shipment of horses he was transporting to New Orleans. When a snake hunter came ashore on Seahorse Key one day to collect some of the many snakes on the island, LeBlanc met him and demanded to know if the man was seeking anything other than snakes (see picture). The man convinced LeBlanc of his innocent intentions and slowly began to make friends with the pirate.

Several evenings later, the snake hunter managed to get the pirate drunk while remaining sober himself. When LeBlanc rose to make his nightly search of the island, the snake hunter silently followed him and discovered where the pirate had hidden Lafitte's treasure. The pirate passed out from drunkenness, and the snake hunter pounced on the treasure chest, broke it open, and began to gather

as many jewels as he could. Suddenly LeBlanc came to, realized what was happening, and attacked the man with his sword. In the fight that followed, the man managed to take LeBlanc's sword away from him and cut his head off with a clean sweep.

The snake hunter quickly gathered up some of the jewels, fled to his boat, and rowed away into the night. When he looked back, he saw the palomino walking back and forth on the island. The story goes that late-night visitors to the island can still see a headless horseman riding a tall palomino around and around on Seahorse Key.

Whether Lafitte ever made it to Seahorse Key or any other Florida site remains to be seen. In any case, people continue to look for the buried treasure of this Frenchman, spurred on by such reports as the following from *Lost Treasures of Florida's Gulf Coast* (pp. 7-8):

DOG ISLAND

This narrow stretch of land, some five miles off the coast of tiny Franklin County, was one of the haunts of the well-known Jean Laffite. The wily old pirate used a unique marker for his three chests of pirate loot buried on the island's southeast corner. A very old palm tree on the eastern tip of St. George Island had a hole bored through it, and a piece of brass tubing was inserted. The instructions on an old yellowed parchment map indicate that sighting through the tube will show where the chests are buried.

To further insure the location of his site,

Laffite (according to the map) chose a spot in the center of a circle of seven very old cabbage palms. All of these were well marked at the time — one with a dagger, another with a large X, and still another with a large skull and crossbones. The map reports a depth of from eight to ten feet for these three chests.

Anyone finding that treasure from the above description is kindly requested to send a sizable proportion of the loot to the author in care of the publisher.

FURTHER READING:

Stanley Clisby Arthur, *Jean Laffite, Gentleman Rover.* New Orleans: Harmanson, Publisher, 1952.

Philip Gosse, *The History of Piracy.* New York: Tudor Publishing Company, 1932; reprinted by Rio Grande Press, Inc., 1990.

L. Frank Hudson and Gordon R. Prescott, *Lost Treasures of Florida's Gulf Coast.* St. Petersburg: Great Outdoors Publishing Co., 1973.

Edwin L. Johnson, "Between Wind and Water," *Nautical Research Journal* (December 1977), pp. 202-206.

J. Ignacio Rubio Mañe, *Los Piratas Lafitte.* Mexico: Editorial Polis, 1938.

Lyle Saxon, *Lafitte the Pirate.* New York: Century Co., 1930.

The Story of Jean and Pierre Lafitte. New Orleans: Louisiana State Museum, 1938.

A. Hyatt Verrill, *The Real Story of the Pirate.* New York: Appleton and Company, 1923; reprinted by the Rio Grande Press, Inc., 1989, pp. 345-355.

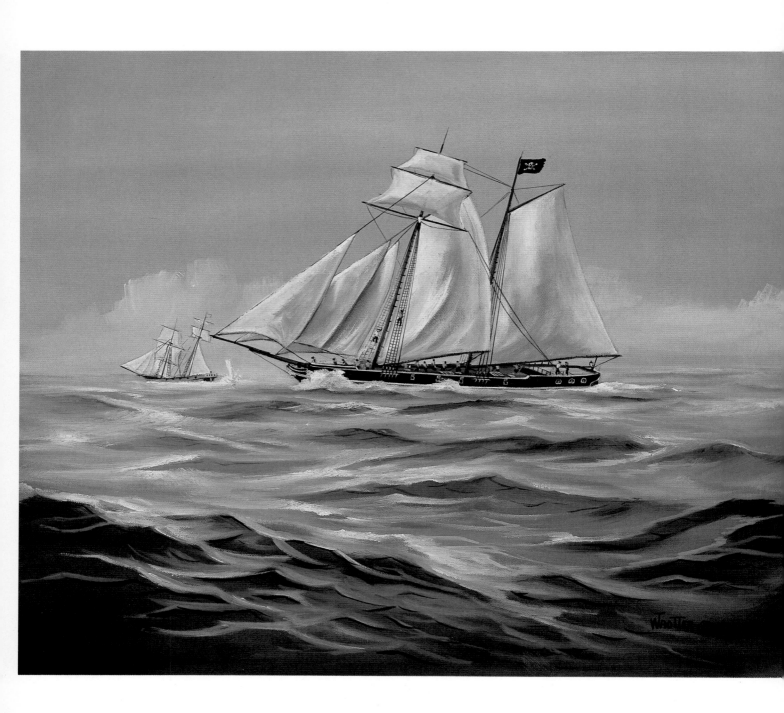

CHAPTER 16

DON PEDRO GILBERT, 1832

Life for those pirates who preferred to lurk among the many islands of Florida's coast rather than actively searching for prey in the sea lanes could be boring and tedious. True, they had to take turns as watchmen on the lookout for passing ships, whether patrol boats or targets, and they had to keep their ships as watertight, free of barnacles, and uncluttered as possible, but many hours passed with little to do. However, once the lookout spotted a ship, the pirates were quick to respond.

In 1832, eleven years after the United States acquired Florida from Spain, few settlers lived along the lower east coast of the territory. That isolation appealed to pirate Don Pedro Gilbert and his crew and allowed them much freedom in attacking ships without fear of reprisal. Gilbert's ship, *Panda*, was a low, sleek, black schooner with a narrow white streak and a large figurehead with a horn of plenty painted white. When one of Gilbert's lookouts spotted the American brigantine *Mexican* sailing off the coast, he signaled to his comrades and they swung into action (see picture).

The captain of the brigantine, Isaac Butman, felt somewhat secure because he had two cannon mounted at amidships. Little did he know that the ammunition he had on board would not fit in the cannons, something he did not find out until it was too late. He did take the precaution of hiding $20,000 in gold in a secret compartment below his cabin, but he felt his crew could ward off any pirate attacks. Despite his boast that he would put up the strongest possible resistance to any pirates, he would be no match for Don Gilbert's ruthless band.

When the pirates spotted the *Mexican*, which was based in Salem, Massachusetts, they took up the chase, patiently following the large merchant ship through the night. When Gilbert came in close to the brigantine, he raised the Colombian flag (he had once had a letter of marque from Colombia which supposedly allowed him to prey on ships), aimed his four cannons on the *Mexican*, and fired a warning shot to have the ship slow down for boarding. When Captain Butman discovered that he could not outrun the *Panda* and that his cannons could not fire the ammunition on board, he knew he was in trouble.

When the pirates swarmed onto the hapless brigantine from their longboats, they mercilessly beat some of the crew, discovered and took out the gold from the hiding place, and made plans to kill the sailors. Gilbert loaded the gold into his longboat and returned to his ship, after giving orders for his pirates to kill the crew of the merchant ship and set it afire.

Instead of killing the sailors outright, as they were ordered to do by Gilbert, for some reason the pirates decided to lock them below decks and set the ship on fire. Either the pirates were too lazy to kill all of the sailors, or they wanted to make the sailors suffer a slow, agonizing death in the fire, or they were thinking ahead to a hypothetical trial ("We

didn't kill the sailors; we only set the ship on fire"). Not killing them outright would turn out to be the pirates' downfall.

While the ship was burning, the pirates returned to the *Panda*, convinced that the sailors would die below decks. Wrong. After the pirates were gone, the captain carefully and quickly worked his way through a skylight to the deck. Once there, he opened the hatches and freed the sailors below. The men then doused most of the fire but kept some of it going, feeding it anything that would cause a lot of smoke, in order to fool the pirates. And it worked.

When the crew on the *Panda* sailed away, they looked back at the merchant ship and saw a huge pall of smoke rising from the spot where they had left it. They figured the ship would sink to the bottom of the sea in a short time and leave no trace of their deed. Little did they know as they sped over the horizon that the sailors and ship were safe and sound.

Although the pirates had destroyed much of the ship, they had not found the compass, quadrant, and sextant that the captain had hidden before they came on board. When the *Mexican* finally made her way back to New York and the sailors told authorities what had happened, the U.S. and British navies began a huge search for Gilbert and his crew.

This particular band of pirates made their headquarters on Hutchinson Island in present-day Martin County. They used the isolated coast to clean their ship of the barnacles it accumulated over the months and also as a cover from which they could observe passing ships. One trick Gilbert liked to use there was lighting a small fire on the beach to lure ships in to see what the problem was. The unsuspecting captain would take his ship as close as possible to shore before launching a longboat to rescue the stranded seamen, something he would have expected others to do if he had become stranded.

Little did he realize, until it was too late, that the "stranded sailors" on shore were part of Gilbert's pirate crew. When the merchant ship hit the reef offshore and began coming apart, the pirates would dash out to loot the ship and do away with the crew. The pirates did this many times in the 1820s, a time when the United States did not have the resources or commitment to rid the area of brigands.

After England and France made peace around 1815, many of their privateers, who had made a lucrative living preying on ships of the other nation, were out of a job. Instead of turning to legitimate work, including seamanship on merchant ships, many privateers turned to piracy to use the skills they had learned on the high seas. One of the more despicable pirates at that time, a man who showed no mercy to his victims, was Don Pedro Gilbert. He was apparently the son of a Spanish nobleman, but had taken to slave trading and rumrunning to make a living instead of farming or trading legitimate goods. When slave trading became too difficult, he would take his ship to Hutchinson Island near Stuart and prey on ships passing offshore, often on their way back to Europe filled with gold and silver.

In 1833, eight months after Gilbert's crew had attacked the *Mexican*, a British naval officer learned that Gilbert was near the west coast of Africa buying more slaves for the transatlantic passage, probably with some of the $20,000 he had stolen from the *Mexican*. After attacking the pirate ship and blowing it up, the British navy captured the pirates and secured them safely below decks in chains. At one point, the pirates escaped to shore, but a native chief was able to exact revenge for the slave catching that Gilbert had done by capturing the pirates and returning them to the British navy.

After taking them to England, the British transferred 12 of these pirates to another ship and took them to Boston to stand trial for the attack on the *Mexican*. Gilbert must have been very surprised to learn that the *Mexican* had survived the fire his men had set and that it had sailed on to New York to report the pirate attack.

In the trial, defense lawyers realized they could not save Gilbert and his crew, but they did succeed in securing an acquittal for the cabin boy, who had been forced to work as a cook for the pirates, and a crewman who had once saved the lives of others. The 16-day trial brought out all the brutality that Don Pedro and his crew had inflicted on innocent sailors. No one was surprised at the verdict that Don Pedro and three of his crew received: death by hanging.

One of the pirates, fearing the hangman's noose, tried to kill himself by cutting his throat with a piece of tin, but guards saved him in time. He was too weak to stand for his hanging, so the executioner

hanged him while he sat in a chair. Guards also discovered that Don Pedro had a piece of glass, which he was probably going to use to commit suicide, but they took it away from him. Don Pedro and his other crewmen were hanged on the gallows in 1834 and became the last pirates executed in the United States. They were also the last of the pirates who preyed on ships in American waters — until their modern-day counterparts.

Today, the reef offshore is called "Gilbert's Bar," and the inlet, which used to be called "Gilbert's Bar Inlet," is St. Lucie Inlet. Ironically, the only remaining house of refuge along Florida's east coast is there, Gilbert's Bar House of Refuge Life-Saving Station, as well as a museum with exhibits of maritime history. Completed in 1876, the house of refuge served for many years as a place where shipwrecked sailors could find food, clothing, and shelter until they could make their way to the mainland. Staffed by just one person, it could house and feed 25 persons for up to ten days.

People have not found any loot that Don Pedro may have buried on Hutchinson Island. Rumor has it that he spent it all, mostly on liquor and women in Cuba. And if Gilbert's Bar commemorates such an awful person, at least the House of Refuge there has managed to cleanse the area of his deeds; as recently as World War II, the watchtower there was used by spotters looking for enemy submarines, a type of 20th-century pirate preying on innocent victims.

FURTHER READING:

Joe Crankshaw, "Last of the Old-Time Pirates," *Mostly Sunny Days: A Miami Herald Salute to South Florida's Heritage*, edited by Bob Kearney. Miami: Miami Herald Publishing Company, 1986, pp. 41-43.

Philip Gosse, *The History of Piracy*. Glorieta, N.M.: The Rio Grande Press, Inc., 1990, pp. 213-23.

Janet Hutchinson, *History of Martin County*. Hutchinson Island, FL: Martin County Historical Society, 1975, p. 136.

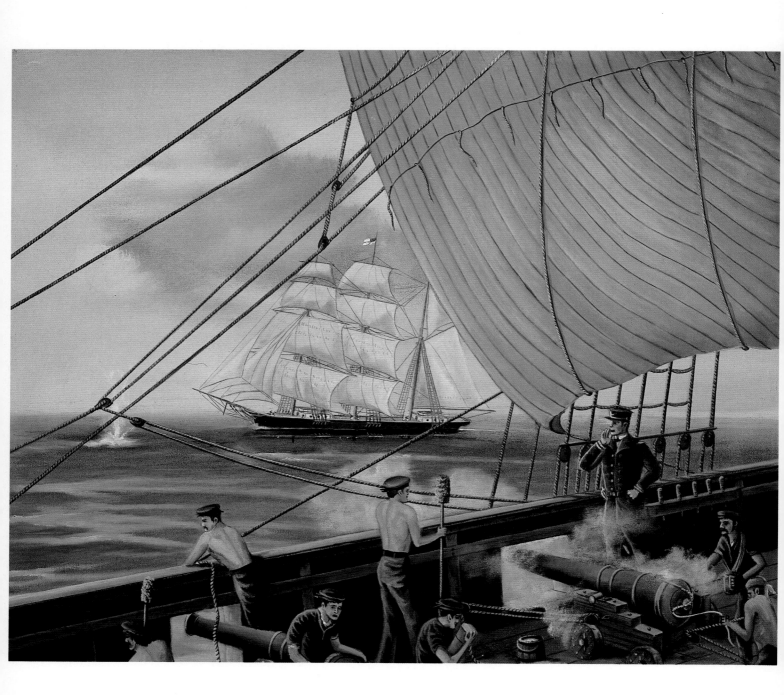

CHAPTER 17

\mathscr{S}LAVE TRADERS, 1860

What exactly was a pirate? Was he always someone who raided helpless ships on the high seas? Was he a brigand, complete with eye patch and sword, who buried treasure on abandoned beaches? Was he someone whom society banished? Or could he in fact be engaged in trade and commerce, even the transporting of slaves from Africa to the New World? It all depended on who was making up the definition of pirate.

In the 18th century, the U.S. government was determined to stop the transporting of slaves from Africa to America. In 1794, it prohibited the outfitting of slave ships in American ports if the ships were going to be used to transport slaves from one foreign country to another. Six years later, the U.S. government denied American citizens the right to transport slaves for sale from one foreign country to another. Seven years after that, in 1807, it outlawed the slave trade between Africa and the U.S. But still that trade flourished as the slave traders simply ignored the law or found ways to flout it. A number of countries had outlawed slavery, and that gave hope to many abolitionists that the institution would die, but the trade continued, and many more slaves died on the way to America or were enslaved in terrible conditions in this country.

Finally, the U.S. Congress had enough. In order to put some teeth into its prohibition of slavery, it passed an 1820 law, the strictest of any nation, that was meant to punish slave-traders as harshly as possible. It declared that such men were pirates and

should be executed. The hope was that this would deter would-be pirates from entering the profession; if not, the government would execute as many slave-trading pirates as possible as punishment and deterrent. The wording of the law was as follows:

If any citizen of the United States, being of the crew or ship's company of any foreign ship or vessel engaged in the slave trade, or any person whatever, being of the crew or ship's company of any ship or vessel, owned in the whole or in part, or navigated for, or in behalf of, any citizen or citizens of the United States, shall...seize any negro or mulatto not held to service or labour by the laws of either of the states or territories of the United States, with intent to make such negro or mulatto a slave, or shall decoy, or...forcibly confine or detain, or aid and abet in forcibly confining or detaining, on board such ship or vessel, any negro..., such citizen or person shall be adjudged a pirate; and...shall suffer death.

"...shall be adjudged a pirate; and...shall suffer death." Strong words! But, as it turned out, not very effective. Several conditions, which are listed below, had to be met for such executions to take place.

If an American was serving on board such a ship or if a foreigner was serving on an American-owned ship, and that ship was engaged in the slave trade, such a person would be considered a pirate by the U.S. government and could be executed. The U.S.

would not execute a foreigner serving on board a foreign ship. Our country was alone in condemning slavery as an act of piracy; other countries did not see slavery as piracy and, in fact, encouraged it.

Pirates were a clever lot. One man by the name of James Smith at first claimed he was an American citizen in order to receive the protection of the United States government. Once captured and charged with being a pirate and therefore liable to be hanged, Smith declared that he was not really an American, but had lied when he had said he was.

He never denied that he was a pirate. He had, in fact, killed 150 slaves on a voyage from Africa to Cuba in 1854. He had packed 664 slaves in his ship to make the transatlantic trip from Africa to the New World; that trip was called the Middle Passage since it was the second part of the Europe-to-Africa, Africa-to-America, America-to-Europe triangle. He did deny, however, that he was an American citizen and claimed that American law did not pertain to him. A jury disagreed with Smith and convicted him of being a slave-trading pirate, the first man ever convicted of that charge in America. However, his lawyer somehow finagled the system and had him plead guilty to a lesser charge, for which he served only a brief time in jail. Only one man, in fact, ever received the death sentence for such piracy.

In the early fall of 1860, just before the American Civil War began, slave traders were still using the Florida peninsula to unload their slaves to be smuggled into other southern states. The many nooks and crannies of the Florida coast provided secure landing places for nighttime smuggling. Slavers preferred sites along the northeastern part of the state near Georgia because they could then have the slaves taken into Georgia, Alabama, and into the Carolinas.

Until 1860, federal forces had captured several slave ships off the Florida coast; for example, the brig *Huntress* and the bark *Lyra*, both in 1858, and the brig *Tyrant* in 1859. All three ships were confiscated. Then on May 9, 1860, federal forces on the U.S.S. *Wyandotte* captured the bark *William* south of the Florida coast after it had come from Havana, Cuba (see picture). On board, Captain William Weston, alias Washington Symmes, had a cargo of slaves destined for the southern states. Officials, who estimated that the crew had put 744 slaves on board

the ship, but that 174 had died en route to Florida, arrested Weston and put him in the Key West jail. Much speculation began about whether he would be the first one executed under the 1820 law.

The answer was negative. In fact, of all the hundreds of such men who could have been executed under the American law for being slave-trading pirates, only one met such a fate. The lack of executions, the lack of forcefulness in the 1820 law, was due to the fact that officials had to meet five conditions for such an execution to take place.

First, American officials had to arrest the pirate at sea with a cargo of slaves. Officials could not arrest the pirates **before** they loaded the African slaves on board, because then the pirates could deny they were in the slave business. Officials could not arrest the pirates **after** they had unloaded the slaves because then they could claim they were not slavers and were not engaged in the slave trade. Federal officials had to arrest the pirates at sea when the pirate ships were filled with slaves; only then would it be impossible for the pirates to deny their culpability. Technically then, the captains became pirates only after they had loaded the slaves onto their ships and before they unloaded them.

Such arrests were very rare, occurring only once before 1858. This was partly due to the fact that so few American federal cruisers patrolled the ocean waters where slavers operated. The British captured many such American slave crews at sea, but usually let them go since the crews were American. If Cuban or Brazilian patrol boats captured slave ships, the officers punished the crews under Spanish or Brazilian law, if at all. The American law applied to the crews and captains, not to the owners of the ships, who usually remained at home, far from the action. Federal officials also needed witnesses who would testify against the slave captain, and that was a rare instance.

The second condition for successful prosecution of a slave-trading pirate was that officials had to hold him for trial. In the days when such pirates had much gold with which to bribe jail officials, holding such men was very hard. Their compatriots were often in the vicinity of the jail and could help them escape; for example, by lowering a rope over the wall or bribing the jailer.

The third condition was the willingness of a lo-

cal community to convict a slave-trading pirate. The 1820 law imposed a mandatory death sentence, something many local communities thought too harsh. As in many crimes, the pirates were not the powerful figures behind the crimes, only the pawns who carried out the directives of the shadowy figures with money and influence. Communities — realizing they could only convict the hired hands, even if they were despicable pirates, and could not touch the many powerful men behind the ventures — were reluctant to pass the death penalty on their hired hands.

American juries might also have considered the fact that the slaves were not Americans, but were foreigners who might have been enslaved by their own fellow countrymen. Southern juries in the 1840s and 1850s were very defensive about slavery and were angry at northern attempts to abolish what many Southerners considered vital to their economy. If such southern juries hanged the slave-trading pirates who had been caught on the high seas, they might worry that Northerners would claim that all southern slave-owners were pirates and subject to the same death penalty. It was probably that kind of attitude that led to the Weston's acquittal in Key West.

The fourth condition to successfully convict a slave-trading pirate was to have the American law cover him. He might get witnesses to say that his slave ship was not American-owned. If papers proved the ship was American-owned, witnesses could be found to say that the real owners were foreigners in another country. Again, the ship had to be "owned in the whole or in part, or navigated for, or in behalf of, any citizen or citizens of the United States...." The crews on the slave ships were often from foreign countries and were very seldom American citizens whose citizenship could be definitely proved.

The pirate might claim that, even though his parents were American, he was actually born on a ship when his mother was accompanying his father on a voyage and that the pirate was born in a foreign territory. One judge, when presented with such a defense, ruled that a person born of American parents, even if they were on a voyage across the seas, was an American citizen.

Finally, if indeed a local community were willing to convict a pirate who was proven to be American and was kept in jail long enough for the trial, he could claim that he had little or nothing to do with the slave trading, that he was merely a passenger on board the ship, that the real culprits were foreigners (who were probably far away at that time). Or he could claim that the captain or (if he himself were the captain) some dangerous men on board had forced him to go along with the slaving venture and that he faced death or abandonment by those evil men if he refused to cooperate.

How could the authorities prove otherwise? The crews on such ships were usually released. Even if they were also jailed with the accused pirate, they might not testify against him, especially if they wanted to hire on as crew members again. How much control a pirate had to have over a voyage before he could be successfully prosecuted was a vexing question for judges. In 1862, one convicted pirate, Nathaniel Gordon, was hanged, but he was the only slave-trading pirate ever executed.

In 1948, the U.S. Congress changed the 1820 law that had made slave-traders pirates. Instead of making slave-traders pirates and therefore subject to the death penalty, Congress declared that slavery was not a capital crime but was to be punished by an imprisonment of seven years and a fine of $5,000.

One final note about slave ships and pirates. The only documented pirate ship that has been successfully salvaged was the *Whydah*, a vessel that had operated as a slave ship in the 18th century. The pirate "Black Sam" Bellamy captured her near the Bahamas in 1717, freed the slaves on board, accepted 25 of the slaves as new members of his pirate crew, and proceeded to plunder hapless ships. Three months later, the ship was wrecked on a sandbar near Cape Cod and sank, drowning Bellamy and most of his crew. In 1982, salvagers found the *Whydah* ten feet under the ocean bottom and began taking out its vast hoard of gold. If the ship ever becomes the center of a pirate museum, as Tampa had planned for awhile in 1993, it will tell the story of pirates and slavers, two of the more unsavory parts of our history.

FURTHER READING:

Warren S. Howard, *American Slavers and the Federal Law, 1837-1862*. Berkeley: University of California Press, 1963.

Bill Lawren, "The Truth about Pirates." *Omni* (June 1987), p. 30+.

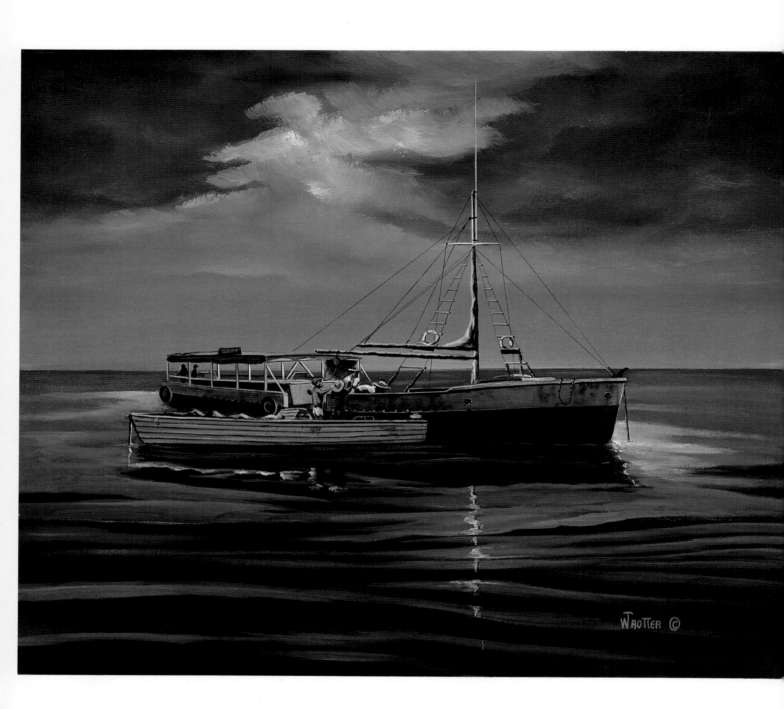

CHAPTER 18

\mathcal{T}HE LIQUOR PIRATE, 1929

Writers called him the "liquor pirate" and "Gulf Stream pirate." Storytellers used such terms as "dashing rogue" and "swashbuckling adventurer." Prosecuting lawyers used the label "murderer of 17 Chinese aliens who had paid him to smuggle them into the U.S." Coast Guardsmen called him "a despicable killer who deserved to hang." All these terms were accurate. The last one led to his execution, but not the curtailing of liquor smuggling.

The 18th Amendment to the U.S. Constitution in 1919 forbade the manufacture, sale, and transportation of intoxicating liquors, except for medicinal and sacramental purposes. When criminals realized that no such law could quench the demands of a drinking public, they came to south Florida to cash in on the lucrative business of smuggling liquor from the Bahamas. From Dade and Broward counties, the liquor would make its way to thousands of speakeasies around the country which were very willing to flout the law. Until Prohibition was repealed in 1933, the chance to amass fortunes by smuggling rum and scotch was too great to resist for too many people.

What rumrunners found in the 1920s was what the 17th- and 18th-century pirates had discovered: Florida's east coast is too long and full of inlets, lagoons, and swamps for the Coast Guard to patrol it effectively. The risk seemed slight to bring in bottles of liquor, which they could buy in the West Indies for $5 a bottle and then sell in Florida for $100. Havana, Nassau, and Bimini became the supply ports

where the smugglers would pick up their contraband before racing at night in speedy boats or airplanes to a drop-off point in Florida.

The Coast Guard tried intercepting as many suspicious boats as possible off Florida, but that proved difficult since the smugglers had very powerful boats. If the Coast Guard couldn't find rumrunners by itself, it sometimes relied on the smugglers to find themselves; when it intercepted and decoded a smugglers' message, the Coast Guard would send out a message implying that some of the smugglers were helping the Coast Guard to trap others. That way, the Coast Guard was able to have the smugglers murder some of their cohorts whom they suspected of informing on them to authorities.

The smugglers, in fact, had a lot more to worry about than being picked up by the Coast Guard. They had to be on the lookout for other smugglers waiting for them on shore to relieve them of their cargo or lying in wait for them at sea. Stealing someone else's liquor, guns, and money and then dumping the bodies overboard with a "cement overcoat" was too easy for the more unscrupulous criminals to pass up. The Coast Guard had stories to tell of finding ships aimlessly wandering the sea lanes with no one on board. The pirates who had stolen the loot and killed the passengers neglected to sink the boat or didn't have time. Or the pirates would leave on board the decomposing bodies of the captain and his crew, all with their throats slit, to "remind" any would-be rumrunners not to hone in on the lu-

crative field of the big syndicates.

As in today's drug smuggling, sometimes large supply ships would wait offshore in international waters. Smaller vessels would dart out from shore, quickly load as much liquor as possible, and speed back to the safety of land under the cover of darkness (see picture). When the smugglers realized the Coast Guard was watching, a decoy boat would rendezvous with the supply ship, pretend to take on board a supply of liquor, and then go off in one direction; when the Coast Guard stopped it, searchers would find nothing illegal on the boat. But meanwhile, another boat would have gone to the supply ship and taken aboard a supply and then gone in a different direction from the decoy. The smugglers called this tactic "belling the cat."

Sometimes, boats would "tow a sub," that is, put the contraband in a small dinghy in international waters, then tow it toward land. The dinghy would sink beneath the surface of the water to about five feet, which made it "invisible" to watching eyes on a cutter. And if a Coast Guard boat stopped a suspicious boat, the smugglers could quickly cut the line to the dinghy and not be found with any contraband on board. "What, there's a dinghy behind my boat floating freely in the sea with a whole lot of liquor on board? I don't know anything about that, sir." Many fishermen hauled in sacks of bootleg liquor that had been cut off or pitched overboard by overanxious smugglers. These packages, called "hams," contained six bottles in a burlap bag full of straw and paper for padding for what might be a rough boat trip from the Bahamas or the supply ship.

If several Coast Guard cutters tried to intercept a smuggler, he might dart in between them, confident that the Guardsmen would not open fire with a machine gun for fear of hitting the other cutters. Or he would try to outrun them, especially if he had a Liberty engine. These were powerful engines that the government had built during World War I but had not used. After the war some boat-builders bought the engines for a low price and installed them in rum boats that could easily outrun the Coast Guard cutters.

For many people, rumrunners had a certain bravado, a willingness to take a risk to bring in something a lot of people craved. People could often point out the rumrunners in their community, those swaggering, well-dressed gamblers who had a certain walk, a certain aura about them. Rich tourists, especially thirsty ones, and unscrupulous hotel owners eager to satisfy visitors' requests for hootch, paid handsome prices to those willing to ferry in good British Scotch or fine Caribbean rum from Cuba and the Bahamas.

All of that changed on August 27, 1927. At about 2 o'clock that afternoon, a Coast Guard patrol boat intercepted a 30-foot boat near Fowey Rocks, 35 miles southwest of Miami. A search of the boat revealed some 50 containers of whiskey bottles destined for the mainland. As the Coast Guard prepared to arrest skipper James Horace Alderman and his mate, Alderman asked if he could retrieve a few personal effects from the boat, explaining that he did not expect to see his clothes again if they remained on the boat.

For some unknown reason, the Guardsman in charge allowed Alderman to reenter his boat without an escort. When Alderman went below and retrieved what he wanted and then boarded the patrol boat for the trip to the mainland, he suddenly drew out a pistol and began firing. He killed two Guardsmen and one Secret Service agent before turning to the rest of the crew.

"I'm going to burn your boat, take you out in the Gulf Stream, and throw you overboard. You're shark bait," he told the Guardsmen who were still alive. Then Alderman's mate, who could not find any matches to torch the cutter, began to argue with Alderman over something. The Guardsmen saw their chance, jumped Alderman, and wrestled him to the deck, but not before one of the Guardsmen lost an eye in the fight.

They brought Alderman back to their Fort Lauderdale base and locked him up in jail. Jail was familiar to Alderman. He had already served time for smuggling liquor and robbing an Indian. He had also been arrested for killing 17 Chinese aliens he had agreed to smuggle into the United States, but was not tried for that crime since evidence was missing.

While awaiting the outcome of his latest trial for killing the three men who had stopped him at sea, Alderman claimed that his 13-year-old daughter, on a visit to him in jail, had converted him to Christianity. Hearing that, several religious groups pleaded

for his life, but to no avail. A federal appeals court judge ordered that he be hanged in Dade County's jail for his crime.

Dade County officials, after hearing the judge's decree, argued that they did not know how to hang anyone. And anyway, maritime law decreed that a pirate, which Broward County had declared Alderman to be, was supposed to be hanged at that port where lawmen first brought him after his arrest. That would be Coast Guard Base Six, so the judge ordered the hanging to take place in nearby Broward County. The execution was set for August 17, 1929, in a seaplane hangar at Bahía Mar.

A federal judge, fearing that a reporter might strap a camera to his body and take pictures of the dying man's last agony, forbade any newspapermen from witnessing the hanging. Witnesses did report later that Alderman spoke only once: "Don't let me die." But it was too late.

Attendants placed a woolen cap over Alderman's face and marched him up to the top of a 15-foot-high platform. As Alderman stood over the trap door, one of the men placed a rope around his neck and pulled it tight. When the executioner released a spring, the trap door sprung open and Aldermen fell seven feet. It took a full 12 minutes of choking and kicking for his body to finally come to rest and for a doctor to declare him dead. Later, more than 8,000 people filed through an undertaker's parlor to see the body of the man who has the distinction of being the only person ever legally executed in Broward County.

One of the Coast Guardsmen who had been on the patrol boat when Alderman killed the men was Hal Caudle, the author of a book on the incident and its aftermath, *The Hanging at Bahia Mar*. Another writer, Marjory Stoneman Douglas, wrote a short story about the incident, "Twenty Minutes Late for Dinner," which referred to the "rummy that got killed."

After the hanging, the U.S. Congress felt pressured enough to pass laws that strengthened the Coast Guard. Money was appropriated for a dozen high-powered destroyers and equipment that enabled the Coast Guard to crack down on the rummies. The large hotels, realizing that the crackdown on the smugglers would cause the tourists to go elsewhere, for example, to Nassau and Havana, pressured officials to transfer the amphibious planes and destroyers back to northern bases and thus curtail the Guard's drug-smuggling efforts.

The repeal of Prohibition in 1933 probably did more to end the liquor smuggling than did the half-hearted attempts by local law-enforcement agencies. Once legitimate companies could legally import all the liquor people wanted, the smugglers chose other contraband, whether illegal aliens of the 1930s or drugs of the 1990s. The pirates of the Gulf Stream continue to prey on shipping, both innocent ships and those belonging to other smugglers.

FURTHER READING:

Patricia Buchanan, "Miami's Bootleg Boom." *Tequesta* No. 30 (1970), pp. 13-31.

Hal M. Caudle, *The Hanging at Bahia Mar*. Fort Lauderdale: Wake-Brook House, 1976.

Marjory Stoneman Douglas, "Twenty Minutes Late for Dinner," *The Saturday Evening Post*, 30 June 1928: 14-15+. Reprinted in *Nine Florida Stories by Marjory Stoneman Douglas*, edited by Kevin M. McCarthy. Jacksonville: University of North Florida Press, 1990, pp. 74-96.

Darrell Eiland, "Rumrunner's Career Ends in Hanging." *Mostly Sunny Days: A Miami Herald Salute to South Florida's Heritage*, edited by Bob Kearney. Miami: Miami Herald Publishing Company, 1986, pp. 152-55.

Don Farrant, "Prohibition Brought Pirates Back to Georgia's Coast." *Georgia Journal* (Fall 1993), pp. 12-13.

Paul S. George, "Bootleggers, Prohibitionists and Police: The Temperance Movement in Miami, 1896-1920." *Tequesta* No. 39 (1979), pp. 34-41.

"Rumrunners Dealt in Booze and Broken Heads." *Florida Trend* (February 1973), pp. 74-77.

CHAPTER 19

ⱰRUG SMUGGLERS, 1977

The headline of the July 1992 story brought the issue of piracy home to many Floridians: "Man tries to pirate Castor's yacht." Florida Education Commissioner Betty Castor, her husband, and two friends had a confrontation with a would-be pirate on a remote island between the Bahamas and Florida that could have ended very badly for the Floridians. That it worked out without any injury was simply due to the pirates' incompetence.

The four tourists had anchored their 35-foot yacht and had gone out in a dinghy to fish for dinner. After they had left their yacht, a man who called himself Prophet Elijah boarded their vessel, took down the American flag, and raised his own Rastafarian flag. When the four returned to their boat, the pirate informed them that the Bahamas had been abolished, he had taken over their boat, and they were to leave. He was accompanied by two other men, a teenager, and a woman.

Castor's husband, lobbyist and former Democratic House leader Sam Bell, later expressed the fear of the four tourists: "The ocean is 6,000 feet deep there. He could have taken us out, sunk the boat, and nobody would have ever known what happened to us."

After a tense half-hour, the four talked the man off the boat, at which point they discovered that he had stolen about $4,000 worth of cash and equipment. They then sailed to Andros, the largest island in the Bahamas, and reported the incident to the authorities, who later arrested the man and charged him with piracy.

That incident turned out well for the would-be victims, but that is not always the case. Take, for example, the mystery of the *Pirate's Lady*. That 75-foot yacht departed from Apalachicola, Florida, on January 27, 1977, with a skipper and deckhand. After it did not arrive in Clearwater when it was supposed to, its owner contacted authorities. What was especially confusing was that no radio contact had been made with the yacht on the day it sailed, something that was highly irregular and suspicious. The skipper and crew were experienced and were not suspected of any collusion with drug runners. The Coast Guard informed the owner that in the case of large missing yachts like the *Pirate's Lady*, a 70-80% chance exists of finding some kind of debris, such as life rafts or oil slicks, if the yacht sank. Although at first the Coast Guard expected to find some debris from the *Pirate's Lady* if it had sunk, nothing from the boat was immediately found.

The following week, the owner contacted the FBI on the suspicion that his yacht had been hijacked or stolen. Four days passed between the time the FBI was contacted about the yacht and when they began their investigation. In those four days a boat the size of the *Pirate's Lady* could travel 1,000 miles, well on its way to foreign ports. Sometime after that, some witnesses claimed they saw the yacht — with various alterations to disguise its identity — in South America, but investigators could not confirm their sightings (see picture).

The Coast Guard had some encouraging news for the yacht's worried owner in that between 1975 and 1977 it conducted 16,227 search and rescue operations. Of that number, 1,762 were missing boats, and all but six of those were eventually found. An insurance company later paid the owner of the *Pirate's Lady* for his yacht, but speculation continued over what had happened to the boat.

Fifteen years later, in late 1992, some of that speculation was answered when divers found the charred wreckage of the yacht in 92 feet of Gulf water 45 miles southeast of Carabelle, a small coastal town southwest of Tallahassee. There was still no trace of the two crewmen, but the safe, with its $15,000 in cash, was missing. The Florida Marine Patrol, which investigated the wreckage, termed it an "unfortunate boating accident," but could not add any details about how or why the yacht sank with no trace of any survivors. That incident seemed to be the stealing of a yacht for purposes of robbery rather than for transporting drugs.

What the stealing of that vessel points to is the growing threat of hijacking and piracy on the high seas involving larger and larger ships. In a 1991 article entitled "Pirates!" authorities pointed out that every year brigands attack and ransack some 120 merchant ships. Professional pirates with grappling hooks, explosives, and powerful speedboats will run down a slow-moving freighter, board her at gunpoint, and steal whatever they want, including the ship itself. And while such brigands stayed away from container ships in the past, more and more they are attacking large ships, including the 80,000-ton U.S. tanker *Ocean City*, the 114,000-ton Greek ore carrier *Konkar Dinos*, and the 120,000-ton Korean tanker *Ocean Runner*.

The pirates can easily fence large cargoes of cement, coffee, car batteries, and steel reinforcing rods through eager merchants in nearby ports who ask no questions about the source of the goods. The Baltic and International Maritime Council, the world's largest federation of shipowners, keeps track of such attacks and points out that a single successful attack can bring in profits of tens of thousands of dollars for the pirates, sometimes over a million dollars for one day's work. London's International Shipping Federation, a group of shipowners, has appealed to local governments to stop the pirates, but usually with little or no luck.

Part of the problem is that ship captains are often reluctant to report attacks by pirates because such losses reflect badly on the maritime skill of the captains and because the pirates have been known to exact revenge on those who reported their attacks.

How do such attacks take place? And where are ships most vulnerable? While the waters off Singapore, the world's busiest port, are the scene of most large-scale pirate attacks by ruthless gangs, any large stretches of open water, including off of Florida, could become the scene of tanker attacks — for several reasons. First, the automation of the large tankers requires fewer crew members to run the ship than in the past. A 23,000-ton container ship can get by with as few as 12 crew members. Second, the men seldom, if ever, carry firearms, both as union policy and as a practice of the shippers. They are no match for a heavily armed contingent of determined pirates. Third, these modern-day Blackbeards have the latest in high technology, such as sophisticated radar and radio-jamming devices that prevent the crew from radioing for help.

Between one and six in the morning, pirates will have their speedy attack boat approach a tanker from its stern — where the few crew members on watch will usually not see it — and then throw grappling hooks over its side and climb aboard. They make their way to the captain's quarters, force him to open his safe, and steal whatever money and valuables they can easily transport. The whole operation may take just 15 minutes — if the captain and crew are lucky.

What is happening more and more, however, is the systematic pillaging of a ship's cargo for sale to a dishonest merchant with a policy of "ask no questions, even if one has doubts about the source of the cargo." Hijackers of ships may paint a new name on a stolen ship, run a new flag up the mast, and repaint enough of the ship to deceive any suspicious authorities. The crew could then take the "new" ship to a port, quote very low rates for the transporting of goods, take on as much cargo as they could, and then disappear into the distance. Say goodbye to that cargo! The ship will later reappear with new papers and a new identity to repeat the scam once more.

How can ships thwart these pirates? By using high-powered lights that scan the area around the

ships. By traveling as fast as they can. By posting watches all around the ship, especially at the stern. Vigilant crew members can aim their fully charged fire hoses, which can have a force of 75 pounds per square inch, at pirates scaling the sides of a ship.

Officials do worry about what might happen if a captain and his crew are battling pirates on board a moving tanker. Or suppose pirates disarm and immobilize the crew of a tanker or chemical carrier, handcuffing them to the rail or throwing them overboard, and then send the crewless tanker on a collision course with the coast, for Florida's Keys or Treasure Coast or Gold Coast. The amount of damage a wrecked tanker could do to the beaches and wildlife of this state might take years to recover from. Hurting or killing a ship's crew is bad enough; hurting or killing many more innocent citizens on shore with an out-of-control ship is much worse.

If governments fail to stop the increasing wave of modern-day piracy on the high seas, shippers may take the law into their own hands and hire maritime bounty hunters who would be paid for each pirate they captured or killed. The stakes, which may reach as high as a million dollars per shipload, are simply too high for shippers to sit back and remain immobilized by the brazenness of pirates. The Blackbeards and Jean Lafittes of today are too brutal, too violent to be allowed to continue unchecked. They are no longer the romantic, swashbuckling, heroic figures that old movies and novels portrayed. Instead, they are ruthless, dangerous, vicious criminals who think nothing of killing the captain and crew of a ship in order to eliminate witnesses and make their own stealing of the cargo easier.

FURTHER READING:

Alan Farnham, "Pirates!" *Fortune* (July 15, 1991), pp. 112-18.

G.O.W. Mueller and Freda Adler, *Outlaws of the Ocean: The Complete Book of Contemporary Crime on the High Seas*. New York: Hearst Marine Books, 1985.

Tom Taylor, "Gulf gives up clue to yacht mystery." *Gainesville Sun*. September 20, 1992, p. 5B.

CHAPTER 20

\mathcal{Y}*ACHTJACKERS, 1993*

Thank goodness the dog had to go out around 10 p.m. that May night. As Mrs. Porter took Suzie out that night, she noticed that something was wrong at the Porters' St. Johns River dock. Their $750,000 yacht, *Pipe Dream*, was gone from its accustomed slip, the same place it had been just one hour before.

Mrs. Porter called to her husband, who rushed out to see what the problem was. Instead of panicking and wasting valuable time, the cool businessman called the police, the U.S. Coast Guard, and the Florida Marine Patrol to report the stolen yacht and then set about to do what he could to recover it himself.

Police later found out that the 24-year-old thief had quietly slipped into the Porters' yard, worked open the locked pilothouse door, cast off six mooring lines and a power cord, turned on the motor, and quietly eased the 53-foot Viking yacht away from the private dock into the St. Johns. He was not planning on using the yacht for smuggling drugs or transporting aliens from foreign countries; he simply wanted to take his buddies for an ocean cruise. But that did not excuse his crime, and in fact authorities could consider him a pirate because he boarded the boat without the owner's permission. Instead of heading north into the Atlantic, the way most thieves would probably proceed, the thief headed south, perhaps to throw off any pursuers who would not expect that direction.

But he was in too much of a hurry. When he reached the Fuller-Warren Bridge south of Jacksonville, he did not decrease his speed as he was supposed to. Lowering one's speed near a bridge will ensure better control of a large boat so it will not cause a heavy wake that could swamp smaller boats. But this thief was in a hurry, and that is what undid him and his plan. When Coast Guard officials began checking with bridge tenders up and down the river, they learned of the pilot who seemed in too big a hurry and figured that that particular pilot might be just the man they were looking for (see picture).

When authorities informed Mr. Porter about which direction they thought the yacht was heading, he swung into action. "We love that boat," he later said. "It's our boat, and we wanted it back." He rushed to a nearby airport, where he kept his private plane, in order to search for the boat from the air. But the airport had just closed for the night, and he had to postpone his search.

Early the next morning, Porter and his son went back to the airport and took their plane up and headed south looking for the stolen yacht. They knew the boat had fuel for only about 100 miles and that maybe the thief had not had a chance or maybe even the funds to refuel. Thirty minutes later they spotted the yacht tied up at a dock in Clay County. They also saw what seemed to be the thief showing off his new prize to some friends.

After letting out a big yell of relief, Porter called the sheriff's office from his cellular phone in the

plane. Several minutes later a police helicopter arrived on the scene and began circling the boat. Instead of fleeing into the woods and hoping to escape on foot, the thief pulled away in the yacht and headed north, somehow thinking he could outrun the helicopter. Five minutes later he crashed into a dock and — with the boat's engine running wide open and the propellers spinning in the mud — he jumped out and ran into the woods. It took just a few minutes for sheriff's deputies on the ground, aided by the helicopter hovering overhead, to arrest the thief.

Porter was relieved. "Don't mess with my boat," he said. The boat sustained some $12,000 in damages from the collision with the dock, but Porter had his boat back and the police had their would-be thief in jail.

Another kind of yachtjacking, one that owners of marinas were unwilling to talk about during the writing of this book, takes place on the high seas. "Books like yours ruin my business and scare people needlessly," one marina owner said. Be that as it may, Captain Roger Villar's *Piracy Today* points out the dangers of yachtjacking to unsuspecting people around the world. Subtitled "Robbery and Violence at Sea since 1980," the book gives details of many piratical acts around the world and includes precautions that the Coast Guard says all yacht owners should practice: know your crew, file a float plan and keep to it, check for stowaways, be alert for unusual situations, contact the Coast Guard before giving assistance to another vessel, and check with local customs agents, for example, with a list of everyone going with you on your trip.

Speculation continues about the *Kalia III*, a 41-foot sloop out of Fort Myers that was found off the Bahamas with blood on its decks and shotgun pellets in its woodwork. In an article entitled "Mean Seas," a drug dealer in Coconut Grove reported that he thought he knew what had happened to the two Fort Myers residents on that boat:

I knew what happened to those two as soon as I heard their boat was found and they were missing. They were just a couple of innocents in the wrong place at the wrong time. Probably came across a drug deal going down or else they just looked like an easy mark. No doubt, they shot the guy and carried off the woman for a little pleasure before they did

her in. They both ended up shark bait. When you come to this part of the world you are in pirate waters, my friend, and that means you can die in a New York second.

Boaters plying the waters around Florida have to be aware of the threat of pirates, especially in these years of drug smuggling. Boat owners are buying more guns and ammunition, and fishermen are hesitant about heading too far without other boats for protection.

Long-time residents of dock areas in south Florida have tales to tell about boats disappearing. Whether pirates captured them for drug smuggling is difficult to say, but the rumors persist on the docks. It would be relatively easy for armed hoodlums to board a yacht at sea, especially after giving a fake plea for help on the radio or asking innocent directions. They could then dispose of the boat's occupants and take the boat to a friendly port for a new paint job, a new waterline for the heavier cargoes, and small alterations to its exterior, maybe even the installation of larger fuel tanks for longer trips.

After a trip to an island with a landing strip to offload drugs flown in from Colombia, or a short trip to a "mother ship" in international waters for taking on drugs, or even to pick up bales of drugs floating in the ocean after being dropped from planes, they could run the boat into Florida waters at night, unload the drugs, and then ditch the boat in the swamps or sink it offshore.

Whereas pirates used to choose large, auxiliary-powered sailboats in the 1970s, lately they have preferred the larger boats, the ones with the latest navigation equipment and advanced radar. The Coast Guard, which has been using the word "piracy" for those who board a vessel without the owner's permission, estimates that some 1,000 pleasure and fishing boats have disappeared in U.S. coastal waters since the mid-1970s. No one can say how many of those were hijacked by pirates for drug use. But some of them must have been.

And that has made boat owners — at least some of them — very cautious. They have installed bullet-proof glass, more powerful engines for escape from pirates, even high-powered semi-automatic 12-gauge shotguns that are accurate up to about 100 feet.

The U.S. Coast Guard has also become much more aggressive in battling pirates and drug smug-

glers. Judges have supported the Coast Guard in its efforts. For example, in 1982 a federal appeals court invoked a maritime principle that dated back to the days of pirates and slavers when it ruled that the Coast Guard could seize drug-smuggling ships at sea without proving that the ships were heading for the United States. The case arose when the Coast Guard arrested nine men some 300 miles from Florida aboard a boat, the *Four Roses*, that had 57,000 pounds of marijuana on it.

The court declared that such a vessel was "stateless," that is, it had no national registration or flew two or more flags interchangeably. Judge Frank M. Johnson said that "all nations have jurisdiction to board and seize vessels engaged in universally prohibited activities such as the slave trade or piracy." Such a ruling has broadened the jurisdiction of countries' law courts and may limit the incidents of piracy around places like Florida where the government is determined to bring pirates to justice.

Chamber of commerce officials may say that the only pirates around are in the Marathon pirate festival or Disney World, but boat owners don't believe that. One lawyer in Key West has petitioned Congress for a "letter of marque and reprisal," which would be the first issued since the War of 1812. Such a letter would allow him to wage a private war against the pirates and keep the spoils of war for himself. He probably will not be granted such permission, but his petition shows to what lengths people will go in order to rid the area of pirates.

So how do captains protect their boats from pirates these days? In an article entitled "Thwarting Thieves & Outwitting Pirates," in *Motor Boating and Sailing*, one expert recommended the following action: 1. Be suspicious of anyone who questions you in detail about your immediate cruising plans; 2. In a strange harbor or anchorage, never allow to board your boat anyone you don't know or have not checked out thoroughly; 3. In remote anchorages, anchor within sight of another vessel unless that other vessel seems to be engaged in illegal activities like offloading drugs; 4. Be wary of any vessel that follows you at the same distance and speed over a long distance; 5. Be cautious with any vessel that approaches you in a remote anchorage, especially at night or at high speed.

Opinions differ about whether to carry guns on board with you. Many feel that if you know guns well, can use them safely, and are determined to use one if necessary, then you might want to take along a rifle like the civilian version of the M-16 with powerful armor-piercing or copper-jacketed shells that can penetrate most hulls. Many yacht-owners also take along pistols, especially the .357 magnum with a three-inch barrel, a stainless steel finish, and copper-jacketed bullets. One must take care to keep the weapons free of the corrosive salt water so prevalent on boats.

The question of whether to declare the guns to local officials is a difficult one to answer; a lot depends on the country. Venezuelan officials will impound your boat and throw you in jail if they find undeclared guns. Mexican officials will confiscate your guns even if you do declare them. If guns are out of the question, consider taking along a lot of magnesium flares and several pistol-style launchers. They may not keep off determined yachtjackers, but they will probably be enough to discourage the more timid among would-be pirates.

Is boating safe these days? Of course it is, if one takes precautions to learn the rules of navigation and to follow the dictates of common sense. Pirates still roam the seas looking for easy prey, but they can be thwarted by boat owners who take care to protect themselves and their boats. Pirates have evolved dramatically from the days of Andrew Ranson and Blackbeard, but they are still evildoers who should be avoided whenever and wherever possible.

FURTHER READING:

Aaron Hoover, "Wild yacht chase." *Gainesville Sun*, May 22, 1993, p. 1.

Teresa Stepzinski, "Yacht owner takes to sky and finds his stolen boat." *The Florida Times-Union* [Jacksonville], May 22, 1993, pp. B1, 3.

"Thwarting Thieves & Outwitting Pirates," *Motor Boating and Sailing* (June 1982), p. 61+.

Captain Robert Villar, *Piracy Today*. London: Conway Maritime Press, 1985.

Michael Wallis and Mark MacNamara, "Mean Seas." *Miami Magazine* (December 1981), pp. 75-88+.

INDEX